AYLESBURY
IN
50
BUILDINGS

PAUL RABBITTS

AMBERLEY

To my dear friend and former colleague Chris Fennell, who once considered moving to Aylesbury but chose Watford instead

First published 2022

Amberley Publishing, The Hill, Stroud
Gloucestershire GL5 4EP

www.amberley-books.com

British Library Cataloguing in Publication Data.
A catalogue record for this book is available from the British Library.

ISBN 978 1 3981 0402 0 (print)
ISBN 978 1 3981 0403 7 (ebook)

Typesetting by SJmagic DESIGN SERVICES, India.
Printed in Great Britain.

Contents

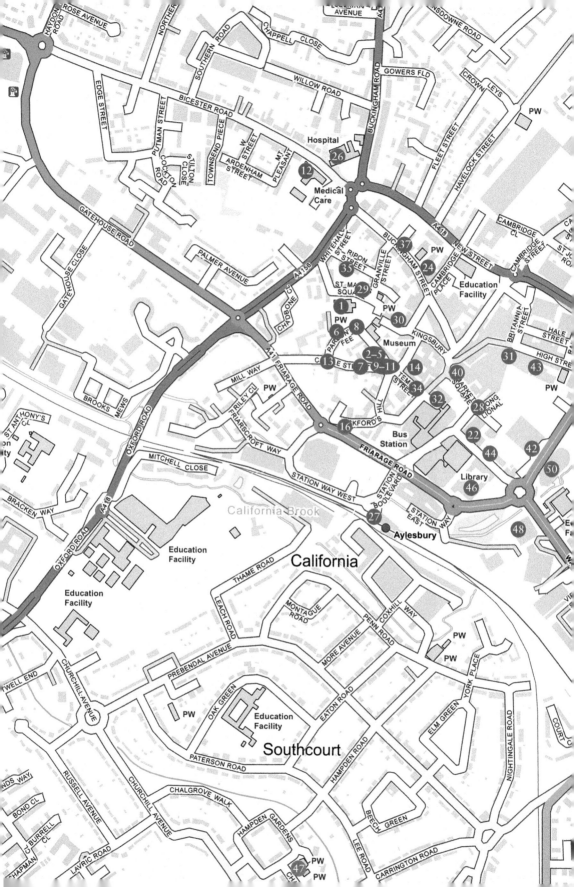

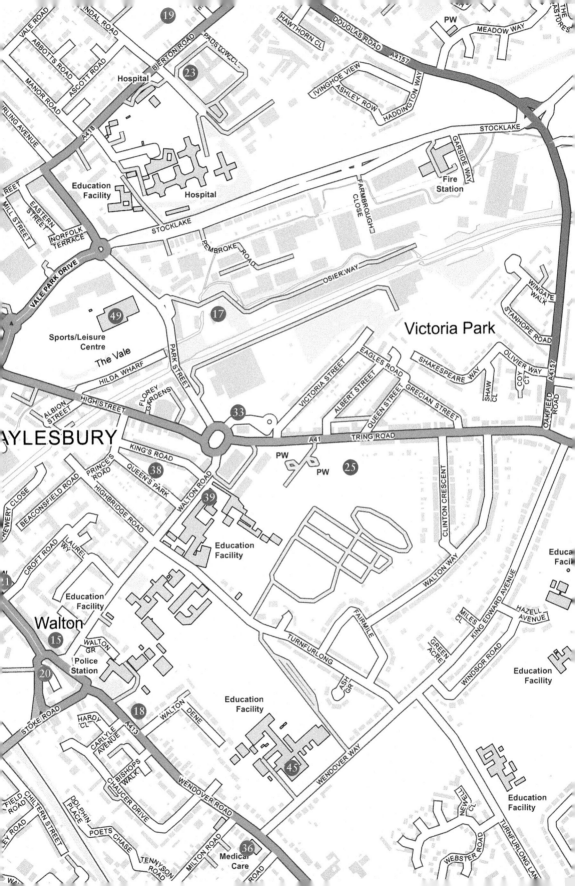

Key

1. St Mary's Church and Square
2. The Friarage
3. The King's Head
4. Greenend House
5. The Chantry, Church Street
6. Parson's Fee
7. Prebendal House
8. Ceely House
9. Friends Meeting House, Rickford's Hill
10. County Hall (and Assizes Courts)
11. Ye Olde Harrow Inn
12. Ardenham House
13. St Osyth's
14. The Green Man
15. Walton Terrace and Walton Lodge
16. Rickford's Hill
17. Hills & Partridge Flour Mill
18. Former New Inn, Wendover Road (now Broad Leys)
19. Former Workhouse and Tindal Centre
20. Former Horse & Jockey Public House (now The Aristocrat)
21. Holy Trinity Church, Walton Street and Adjacent Vicarage
22. The Bell Hotel
23. HMP Aylesbury
24. The Old Aylesbury Bank
25. Aylesbury Cemetery
26. Royal Bucks Hospital
27. Aylesbury Railway Station
28. The Corn Exchange
29. Former Derby Arms
30. Former British School, Pebble Lane
31. Former Congregational Church, Hale Leys
32. The Clock Tower
33. Hazel, Watson and Viney Print Works Gate Lodges
34. Former Literary Club
35. Masonic Hall, Ripon Street
36. Byron, Milton and Spenser Villas
37. Methodist Church, Buckingham Street
38. The Former Queens Park County School, now an Arts Centre
39. Aylesbury Grammar School
40. HSBC, Market Square
41. Hampden House
42. Old Aylesbury Police Station
43. Former Gala Bingo
44. County Offices
45. Grange School
46. New County Hall
47. Guardian Angels RC Church, Southcourt
48. The Blue Leanie
49. Aquavale Leisure Centre
50. Waterside Theatre

Introduction

The towne selfe of Aylesbury standeth on an hill in respect of all the ground thereabout, a 3 mile flatt north from Chiltern Hilles. The town is meetly well builded with tymbre, and in it is a celebrate market. It standeth in the high-waye from Banbury to London, and Buckingham to London.

John Leland, 1506–52

The centre of Aylesbury is compact, with an intricate and interesting sequence of squares, and the church in its churchyard lies away from them. There are plenty of enjoyable buildings, Georgian, just pre-Georgian, and just post-Georgian, but nothing of the first order.

Nikolaus Pevsner, *The Buildings of Buckinghamshire*, 1979

Aylesbury, the county town of Buckinghamshire, is a busy market town that has changed considerably over many centuries and continues to evolve into a twenty-first-century town serving the residents of Buckinghamshire. The name 'Aylesbury' is thought to be a derivative of 'Aigle's Burgh', meaning 'hill town' or 'fort'. Excavations in 1985 on a site adjacent to Nelsons Terrace and Oxford Road in Aylesbury old town found the remains of an Iron Age hill fort dating back to 650 BC.

The Romans built Akeman Street, which runs through Aylesbury Vale today as the A41. This was part of the major road network they constructed throughout Britain, built initially for moving troops and equipment quickly from one base to another. It ran for 78 miles from Verulamium (St Albans) to Corinium (Cirencester). Later this military convenience served to facilitate the rapid growth of Romano-British trade and commerce. The Romans left Saxon mercenaries guarding Akeman Street, and the remains of a Roman-British settlement from the first and second centuries were discovered in 1979 in Buckingham Street where Sainsbury's supermarket now stands.

In 571, Cuthwulf and his army of Anglo-Saxons drove the resident Celtic Britons out of the area. Later the Danes came, ousted the Anglo-Saxons and settled in their place, but they in turn were overrun in the tenth century by Edward the Confessor's troops. Around ninety years of instability then followed and the area was not peaceful until after the Norman Conquest of 1066.

Aylesbury was given its charter and borough status in 1554 by a grateful Mary Tudor, in appreciation of the town's loyalty in declaring her Queen of England

against the competing claims of Lady Jane Grey. It was during the English Civil War that Aylesbury became prominent. At the Battle of Holman's Bridge in 1642 the defence of Aylesbury was led by John Hampden, cousin to Oliver Cromwell. As an MP, John had opposed Charles I on the Ship Money issue, refusing to pay the tax that was being levied to underwrite an expansion of the Royal Navy. A bronze statue at the top of Market Square commemorates Hampden's contribution to the Parliamentary cause. Another radical MP for Aylesbury was John Wilkes, who spent time in the Tower of London during the eighteenth century after being accused of seditious libel. For a time he lived in Prebendal House with his first wife, Miss Mead, who was ten years his senior.

In the early eighteenth century, Aylesbury gradually assumed the role of county town from Buckingham. The Summer Assizes and the law courts moved here in 1707 and this took much trade away from Buckingham. In 1725, a terrible fire in Buckingham destroyed much of the town centre and made more than 500 people homeless. This confirmed Aylesbury as the centre of government for the county and thus began a period of building numerous civic buildings.

During the nineteenth century Aylesbury developed links with transport networks connecting other parts of the country and the town was to thrive and expanded rapidly. The Aylesbury Branch of the Grand Union Canal was opened in 1814 and is thought to have been used as a staging post in the transportation of slaves, before slavery was abolished. In 1839 Aylesbury was the first place in the world to have its own railway branch line. The Great Western Railway built a branch line from Princes Risborough in 1863 and the Metropolitan Railway arrived in 1892. A connection to Buckingham was completed in 1868 and in 1899 Aylesbury was finally on a main line from London to Manchester when the Great Central Railway arrived.

The town grew very slowly from medieval times until the beginning of the nineteenth century when the population of Britain started to increase generally. The 1811 census showed that the population of Aylesbury was 3,447; the 1841 census recorded 5,414 residents, and in 1901 it was 9,243. The number of townspeople increased steadily until the 1960s, when Aylesbury was selected as an overspill town for Londoners and a massive housing expansion took place. At the same time, the centre of Aylesbury was extensively renovated and modernised. By 1995 the population had increased to about 60,000. This has risen to roughly 65,000 in 2008 but is expected to reach 100,000 over the next twenty years.

Most of the older buildings in Aylesbury, many of which feature in this book, are to be found in the streets surrounding Market Square, St Mary's Square, Kingsbury and Church Street. Predominantly Georgian in character, with some small Tudor and Jacobean enclaves, the Old Town is home to the King's Head coaching Inn, the County Museum with the Roald Dahl Children's Gallery, and the eighteenth-century Prebendal House, once the residence of MP John Wilkes.

The Market Square has unfortunately lost most of its historic buildings, with many incongruous introductions that many feel has ripped the heart out of historic

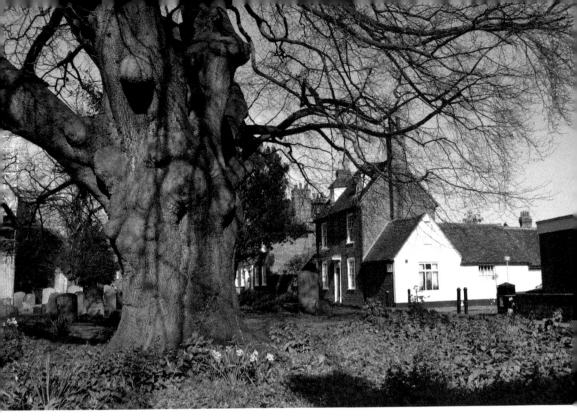

St Mary's Square, where many of the town's oldest buildings can be found.

Aylesbury. At its centre it also has the clock tower, completed in 1877 and thought to stand on or close to the site of the original guildhall of Aylesbury. The rich and fertile loam of the Vale of Aylesbury was perfect for farming and husbandry and from 1204 until the end of the twentieth century there was a twice-weekly sheep, pig and cattle market in the square. The many ponds and waterways in the Vale supported the development of the then local specialty, the Aylesbury duck. The duck, pure white, with a flesh-coloured beak and bright orange legs and feet, was valued by chefs for the richness of its flavour.

Old, established family shops surrounded the square in the eighteenth and nineteenth centuries. For example, Augustus Lines, the grocery and tea emporium, offered 'Teas genuine as imported by the Honourable East India Company' and other commodities such as vinegar, hops, local bacon, spices, fruits, etc. It was also possible to purchase chandlery, haberdashery, drapery and saddlery in the marketplace.

At the bottom of the Market Square are the impressive Crown Courts. Criminals sentenced to be hanged were once publicly executed from a balcony on the front of the courthouse. Spectators used to pay for a place on the balcony of the Green Man Inn to get the best view of this grisly spectacle. The lions in front of the courts were given by Baron Ferdinand de Rothschild of Waddesdon Manor in 1888. Adjacent to Market Square and through a linking thoroughfare is Kingsbury. Many properties here also have interesting histories.

During the 1950s and 1960s thousands of new homes were constructed in Aylesbury to relocate Londoners. This was followed by extensive redevelopment of the town centre. Some Aylesbury residents regretted the demolition of ancient buildings and the loss of old street patterns, but others welcomed the growth and investment.

Friars Square Shopping Centre was opened in 1967 to provide much-needed functional modern retail units to meet the demands of the growing population. Originally the market relocated to the new centre, but in 1990 Friars Square was demolished and refurbished into a modern indoor shopping mall and the market moved back to its natural home in the Market Square. Hale Leys Shopping Centre was opened by Diana, Princess of Wales in 1981.

The increasingly complex administration requirements of the county were given much-needed new accommodation in the twelve-storey County Hall, opened in 1966. Designed by F. B. Pooley, the county architect at the time, the building heralded a brand new age for the then sleepy market town of Aylesbury. At the time the *Bucks Herald* ran a special six-page supplement and in it Fred Pooley, the county architect, commented that 'most new buildings which have represented an advance in architecture have had to bear a great deal of criticism and I accept that as a piece of architecture it (the county offices) will be judged by history either as a miserable failure or as a building which made a contribution to the development of world architecture'. It is fair to say that no other building in Aylesbury has had such a love-hate relationship with the people of the town, and forty-two years on it continues to be controversial. In November 2016, the *Bucks Herald* reported:

> Known as 'Pooley's Folly' after celebrated architect Fred Pooley, it has been immortalised with Grade II listed status.
>
> A beacon of the town, the building's Brutalist style wouldn't look out of place in a J.G Ballard novel, or a dystopian fiction. It is visible from miles around – it gives us a strange reminder of the zenith of the brutalist architecture and the then architectural visions of future buildings, with its morass of glass and concrete.

The former Aylesbury Vale District was the fourth fastest-growing local authority in the south-east of England. It has grown rapidly in recent years, mainly as a result of the increase of housing in the district. On average, 750 new houses are completed every year. When the government decided that Aylesbury Vale should be a major area for further growth in the south-east it stipulated that the larger Aylesbury Vale must be built through a sustainable development programme, thus planning not simply more houses but also new jobs, improved infrastructure and a protected and enhanced environment.

New developments in Aylesbury Vale are now concentrated in the town near existing services and its retail centre. Approximately 18,300 new houses were to be built by 2021 and five out of every six were proposed to be in Aylesbury. On the town's periphery the major development areas of Weedon Hill will eventually

provide 850 homes and Berryfields 3,000 homes. This is a phenomenal growth rate and affects the existing infrastructure of the historic town of Aylesbury.

In 2022, an unofficial poll voted Aylesbury the 'worst place in the country to live', with second place going to Huddersfield. These so-called polls have also voted places like Luton, Middlesbrough, Hartlepool and Cambridge as some of the worst places to live, and Milton Keynes as one of the best places to live. In this author's view, such polls are meaningless and, to be honest, insulting to the thousands who have made these places their home. While the town centre may be struggling, a quiet stroll around the old town of Aylesbury and appreciation of its history should quell such a myth.

The 50 Buildings

The Church of St Mary is situated at the highest point within a square lined by buildings, which Pevsner described as 'houses so designed and accidentally grouped that they form a setting which suits the Church everywhere, and occasionally heightens its impressiveness'. The church dates from the thirteenth and early fourteenth centuries, but was 'recklessly restored' according to Pevsner, and heavily altered by Sir George Gilbert Scott from 1849 to 1855 and 1866 to 1869.

There was a Saxon church at Aylesbury by the ninth century, and possibly one even earlier than that. From Saxon times Aylesbury has been the ecclesiastical centre of the county, receiving payments in grain from the surrounding area. The church we see today was built in the first half of the thirteenth century on the highest point in town. It was later extended in the fifteenth century but suffered badly in the English Civil War. In 1642, one of Cromwell's men, Nehemiah Wharton, wrote that the vicar Penruddock, 'a Papist', was set upon and his church windows defaced, and the 'holy railles' burnt. After the war the church moved out of the bishop's patronage. The adjacent Prebendal House was in the hand of Wilkes by 1767 when the vestry determined to erect a gallery in the church, and he sat on the relevant committee. In 1765, a surveyor named Mr Keen reported on the poor state of the building; his view was that 'it might not stand until he got to Watford'. There was little response. By 1781 the gallery project came up again and a faculty was obtained to build it. But by the nineteenth century part of the church was used as a fire depot, and before that it had done duty as a gunpowder store. In 1848, the bell fastenings gave way, there was panic among the congregation, and eventually architect George Gilbert Scott was brought in.

The same year Scott delivered his report, which was scathing of the condition of the building. His report revealed:

> Universal failure of the foundations, scarcely one wall or pillar which has not gone out of the perpendicular, the four great piers of the tower buttressed up in all directions to keep them standing, the pillars of the nave lean westward to a frightful extent, the south wall of the nave is terribly crooked, even the porch follows the general fashion of the building by spreading on both sides.

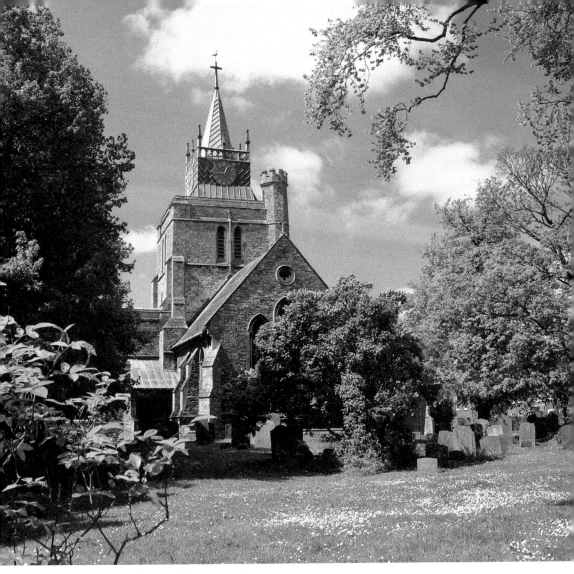

St Mary's Church, which dominates the square.

This was no surprise as the foundations consisted of loose stones and earth thrown in anyhow and with no cement used at all. The roof of the nave had decayed, and the clerestory walls were bulging. This succession of failures went back many decades, with little effort to resolve them. Scott said the bodies buried near the church would have to be exhumed and removed, concrete poured into foundations, and iron ties put to the tower. The stonework would have to be replaced piece by piece to save the latter, and new timbers inserted. In 1855, the initial restoration was implemented and by 1869 the final touches completed. In 1870, new stained-glass windows were installed. In all, £16,000 was spent. (£1.75 million based on 2022 figures). 'Not a stone was left unturned and hardly a corner of the church was left untouched' was how one anonymous observer described these works.

However, once again, a building that is centuries old is in need of restoration, and at the time of writing, scaffolding has been erected as further works are carried out to ensure St Mary's remains the ecclesiastical centre of Buckinghamshire.

Not surprisingly, the square surrounding the church is called St Mary's Square. It is asymmetrically shaped, and the church is located towards its north-western end. Five main points of access converge on St Mary's Square; these are Nelson Terrace from the north-west, Granville Street from the north-east, Pebble Lane and Church Street from the south-east, and Parson's Fee from the south-west.

Trees form an important part of the character of the square, providing a shady oasis of green within this historic urban setting, containing views, reinforcing the sense of intimacy and enclosure and acting as a foreground and backdrop to views of the church and surrounding buildings.

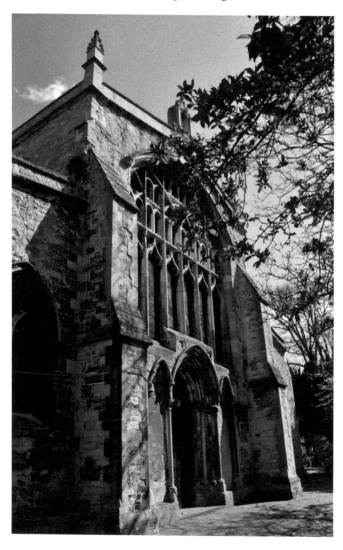

Remodelled by Sir George Gilbert Scott, but Pevsner was critical.

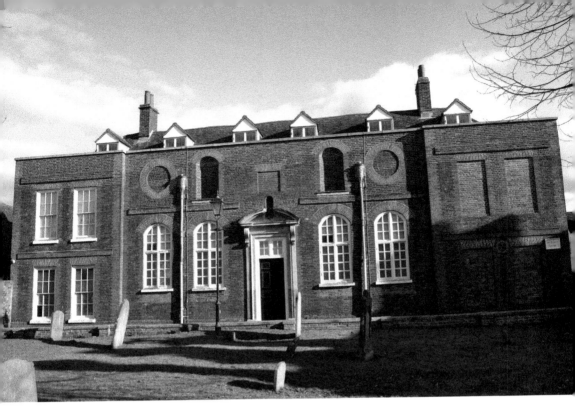

Above: St Mary's Square and the rear of the museum.

Below: St Mary's Square – accidentally grouped according to Pevsner, adding to the architectural quality of the square.

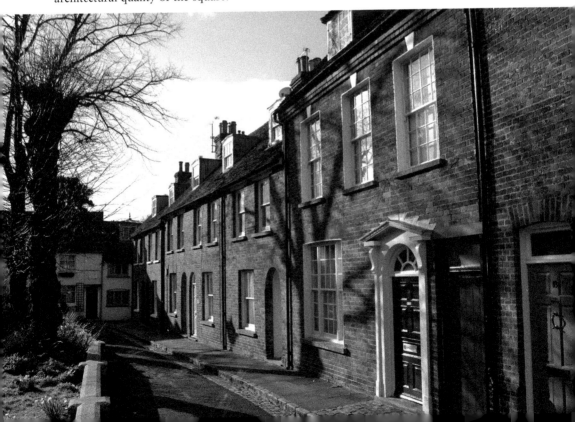

Pevsner's description of the buildings that line St Mary's Square as being 'accidentally grouped' perfectly captures the picturesque charm and eclecticism of this area of the town. Dramatic contrasts result from the juxtaposition of the majestic form of the church set within the verdant churchyard and the tightly grouped vernacular buildings that enclose it on all sides. The south-western side of the square is dominated by Prebendal House, which is set back within substantial grounds and separated from the churchyard by a high brick boundary wall. William Mead, a London merchant, originally constructed the building in the early eighteenth century. It was purchased by the politician John Wilkes who, during the 1750s, remodelled the house in keeping with the Palladian tastes of the day. During the nineteenth century the building was radically remodelled by Thomas Tindell, who inserted an additional floor and constructed a hipped roof. The principal elevation of the building faces the churchyard, although the entrance gate, which consists of an impressive brick archway with keystone set between rusticated brick piers and curved flanking walls, is located off Parson's Fee.

2. The Friarage

This building, the former Friarage at No. 14 Bourbon Street, is the oldest building in Aylesbury that was used as a residential dwelling. Constructed around 1386 as a Franciscan priory, the substructure remains intact, although the exterior is more modern. Part of the original foundation of the building can still be seen at the side in Friarage Passage.

It is possible that the building was refronted shortly after the Dissolution of the Monasteries by Henry VIII in the sixteenth century. Refronting was a common practice in British building techniques and involves stripping away the external shell of the older building, sometimes just the front, and then adding a new shell.

This building in particular is discernible as a much older building than it looks because of the uneven windows at the front. One will notice that no two windows are on the same level or of the same size. This indicates a more organic growth of the building over many years rather than one that has been specifically designed to look a particular way – this is a common feature of buildings of this age.

There is a high likelihood that the building was refronted for a second time or had extra features added to it in the eighteenth century; the front door, for instance, is of a much later design than sixteenth century. However, records suggest that the size of the doorway and the position of the windows are original features from the fourteenth-century structure. Today the building is the main office for a firm of solicitors who have been based in this building since the firm was founded – it had been the private residence of one of the firm's first partners.

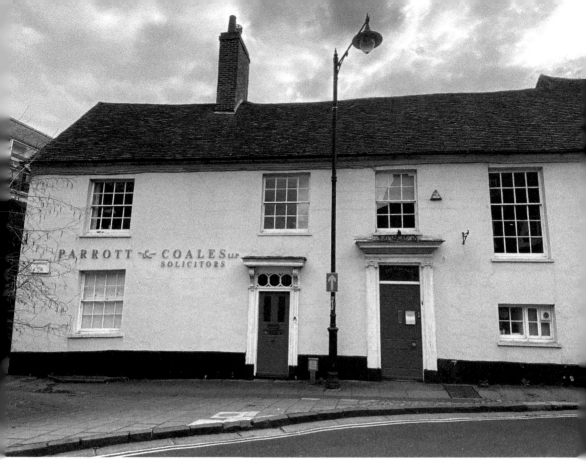

The former Friarage, now home to one of the oldest firms of solicitors in Aylesbury.

3. The King's Head

The King's Head holds a very special place in the history of Aylesbury and has been more than just a pub, having a variety of multifunctional uses including a tourist office, a coffee shop also selling second-hand books, and a florist.

History records that the King's Head has always been multifunctional. The building dates back to 1386, and perhaps even earlier. The first buildings on the site were where the Farmers' Bar is now situated and consisted of three shops and a cottage. There was a cellar underneath one of the shops, accessible by steps from the street. This was a tavern called the King's Head (Kyngshede) and would almost certainly have been named after the reigning monarch, Richard II. The shops and cottage would have had lesser buildings attached, with a ground-level hall and parlour, and sleeping quarters on the first floor. All that remains of these buildings is the cellar underneath the Farmers' Bar. These early buildings would actually have overlooked the Market Square. In medieval times Kingsbury was the centre of the town and would have been much larger than it is today. The same was true of Market Square. Market stalls gradually became permanent and eventually

became shops, houses and inns. The area between Kingsbury and Buckingham Street were a later encroachment, as are the shops in front of the King's Head and on the west and east sides of that square.

In 1382, James Butler, 2nd Earl of Ormonde, granted the Friars Minor of England 10 acres in Aylesbury to found a Grey Friar's (Franciscan) Friarage. It was located in an area near to the current Friarage Passage, Rickford's Hill and Friars Square Shopping Centre. As the King's Head buildings were adjacent, they would certainly have been used as lodgings for passing visitors to the monastery.

In the mid-fifteenth century Sir Ralph Verney, the Lord Mayor of London who played a major role during the Wars of the Roses, acquired the King's Head properties. The properties had been purchased in 1455 by William Wandesford, who had served in the household of Margaret of Anjou. Unfortunately for him, he was a Lancastrian during the Wars of the Roses and had to forfeit his estates in 1465 to Verney. Between 1480 and 1485 Verney set about demolishing some of the older buildings and acquiring adjacent land to build a great hall to house his important guests, who, like Verney, were invariably successful London merchants.

In the Great Hall today are wonderful stained-glass windows. Each of the five panes commemorates a connection with the period when the inn was built:

The King's Head, dating back to 1386.

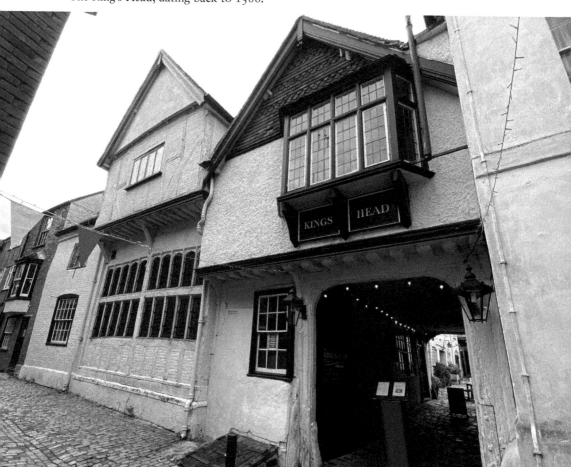

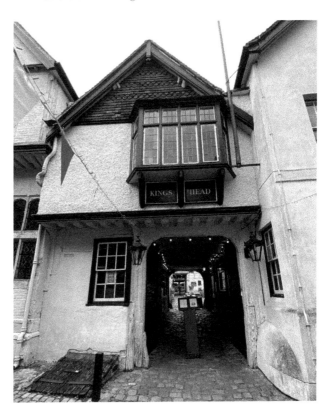

The entrance to the historic courtyard of the King's Head.

Edmond Beaufort (d. 1455), royal courtier, soldier and supporter of Henry VI in the Wars of the Roses; Henry VI (1421–75), king at the time of the construction; William de la Pole (1396–1450), Earl of Suffolk, who played important role in marriage of Henry VI to Margaret of Anjou; Margaret of Anjou, Henry's queen, and the owner of the King's Head, William Wandesford, who served in her household; James Botlier, the 4th Earl of Ormonde (White Earl) (1390–1452); the descendant of the 2nd Earl of Ormonde Shield, and founder of the Grey Friar's monastery nearby.

Other features of the Great Hall include a case on the wall showing the original wattle and daub under the plasterwork, evidence of the original smoke hood inside the chimney and steps used by sweeps, hazelnuts for insulation found between the floorboards and glass in the door dated circa 1700.

By the late fifteenth century Verney had extended the Great Hall with a parlour, a secret room above and a kitchen. With the addition of the first gatehouse and stable accommodation, the area around the courtyard was complete. Traces of the past can still be seen in the courtyard today: an eighteenth-century mounting block, a lamp holder for burning rags, hooks for unloading meat (which was used until the early twentieth century), and some original cobbles. The old hotel reception office was originally used as an early post office. The stables, which are the only remaining example in Aylesbury, were built in the early nineteenth

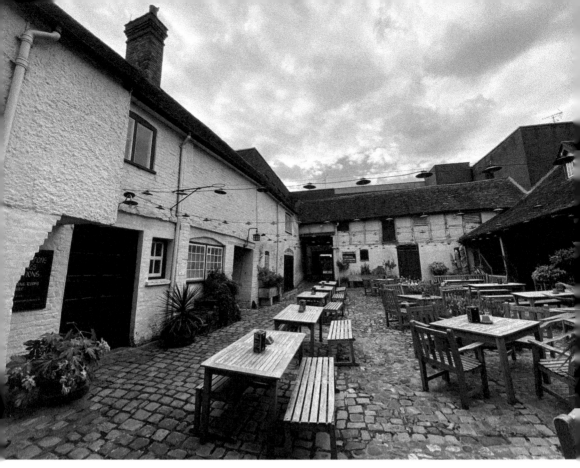

The courtyard to the King's Head.

century, replacing the sixteenth-century originals. They were nearly destroyed in the 1930s to provide space for garaging, but fortunately survived.

In addition to the court of Henry VI, the King's Head has been connected to other famous people such as Anne Boleyn, Oliver Cromwell and the Rothschilds. Today that connection carries on in the tales of ghosts and 'presences' such as a lady in grey seen in the Great Hall, a pint pot seen to float mysteriously, an apparition of a nun seen in the old panelled dining room, an aroma of spices in the corridors and a 'presence' in Cromwell's bedroom.

4. Greenend House

The most substantial and possibly the finest building situated along Rickford's Hill is No. 10 Greenend House. The building is set back on the north-western side of Rickford's Hill opposite the junction with Bourbon Street. In front of the building is a low boundary wall topped by a dense hedge and in front of this the pedestrian area has been extended and a single tree provides a focus to views. Greenend House dates from the sixteenth century, although the principal

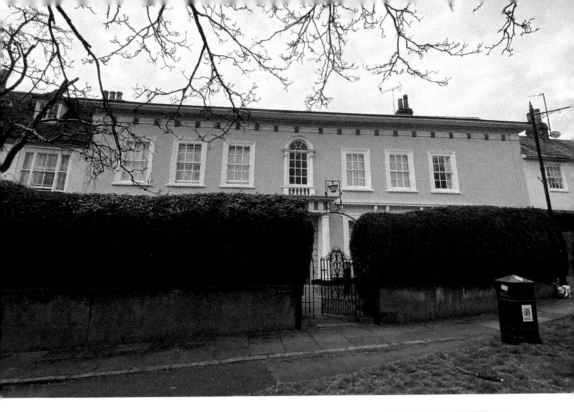

Above: Greenend House, almost hidden from view by its high hedge.

Right: Greenend House and its impressive entrance.

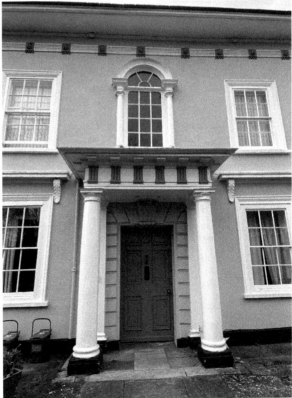

elevation was remodelled by William Rickford during the late eighteenth and early nineteenth centuries. The handsome stuccoed elevation is two storeys in height and articulated with classical motifs. Of particular note are the carved lion heads positioned beneath the eaves. The roof is shallow in pitch and covered with natural slates. The main gates to the building are also worthy of note and are late eighteenth or early nineteenth century in date.

5. The Chantry, Church Street

The Chantry on Church Street is a sixteenth-century building, but was considerably altered in the 1840s. The building has an unusual elevation, with no other house in the town similar in style. It has three barge-boarded gables and windows with hood moulds, with those on the first floor having heads depicting English poets.

By 1864 the house, then known as Oak Hall, was occupied by Robert Gibbs, the well-known editor of the *Bucks Advertiser* and author of *The History of Aylesbury* as well as other publications on local history. Gibbs and his wife are buried in the churchyard at Stoke Mandeville.

The Chantry, once the home of Robert Gibbs, author of *The History of Aylesbury* (1864).

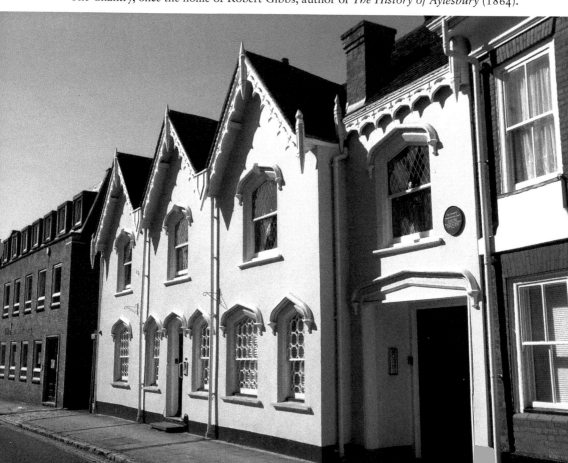

By 1895, Mr William Lowndes and his family were residents but had left by the early 1900s and Robert G. Thomas, the county surveyor, was living here by 1907. He was one of the town's earliest motorists, owning a Vulcan automobile, and lived here until around 1920. By 1921, Dr A. W. Duncan Coventon, a physician and surgeon, bought Dr J. C. Baker's practice, which had been run for many years

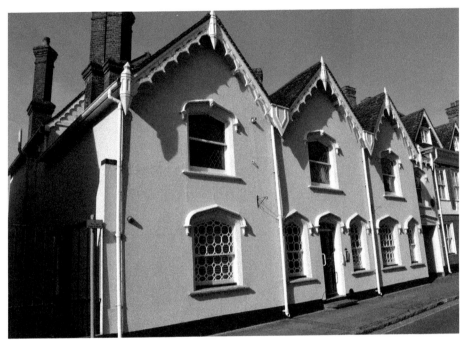

Chantry House, a house of unique style in Aylesbury.

William Shakespeare looking down.

from Ceely House on the opposite side of the street. Dr Coventon practised at the Chantry from the early 1920s and when he retired, soon after the last war, the practice was transferred to Dr Peter Gimson, who retained it until his retirement in June 1975. It remained in private hands as a residence until 1990 when the Thomas Hickman's Charity obtained it and converted it into residential units.

6. Parson's Fee

Parson's Fee has a name steeped in history. Aylesbury remained a feudal manor until the thirteenth century when new smaller landholdings were formed. These new, small manors created by royal grant were often known as fees. Aylesbury had several fees around the reign of Henry II. These included the Castle Fee, held by the principal lord of the manor of Aylesbury, who also held the Lord's Fee; the Otterer's Fee, which was granted to Roger Foll, the king's otter hunter in 1179; and the Church Fee, endowed to the church, which eventually in Aylesbury was allowed a small degree of autonomy as a prebend of the diocese of Lincoln. The Church Fee was therefore controlled by the 'parson' or priest of Aylesbury, and thus came to be known as Parson's Fee.

This row of cottages adjacent to the parish church are some of the oldest dwellings in Aylesbury. These timber-framed dwellings, which date from the seventeenth century, have oversailing upper stories, a common feature of the

An old view of Parson's Fee.

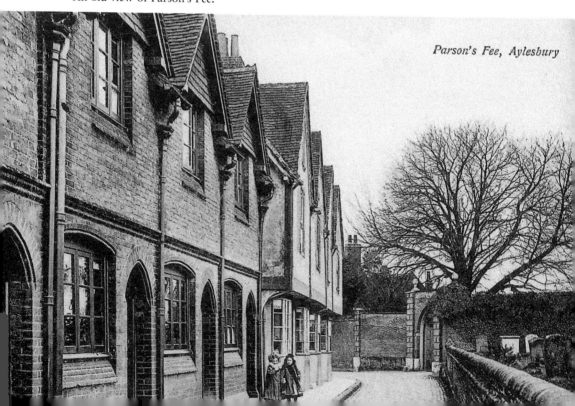

Parson's Fee, Aylesbury

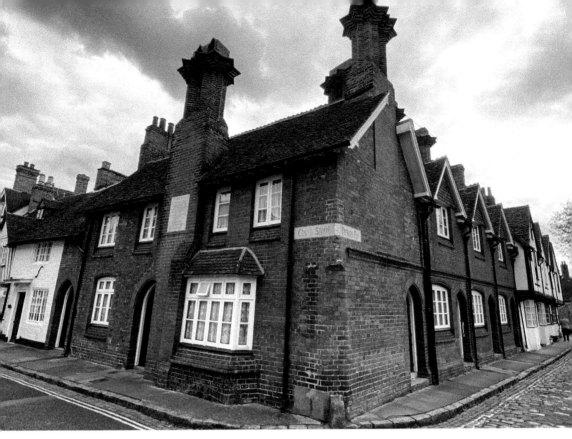

Above: The Hickman Almshouses on Parson's Fee.

Below: Gothic in style, the Hickman Almshouses.

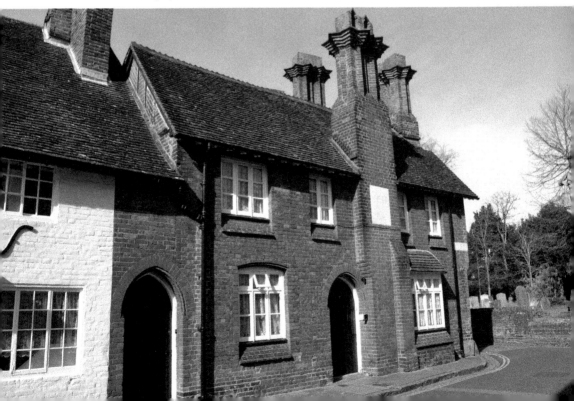

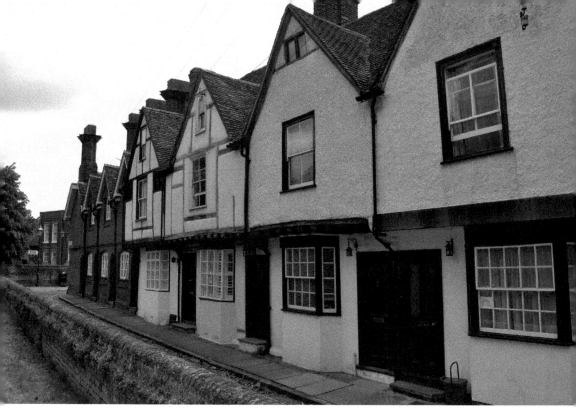

These date from the seventeenth century and are some of the oldest buildings in Aylesbury.

period, which had the advantage of increasing the space of a small land site. The Gothic-styled, brick-built cottages are almshouses belonging to the Thomas Hickman charity. Thomas Hickman was a resident of Aylesbury in the seventeenth century who left money in his will to provide money for dwellings for the old and infirm. These dwellings were built in the nineteenth century to look like their neighbours.

7. Prebendal House

Pevsner's description of the buildings that line St Mary's Square as being 'accidentally grouped' perfectly captures the picturesque charm and eclecticism of this area of the town. Dramatic contrasts result from the juxtaposition of the majestic form of the church set within the verdant churchyard and the tightly grouped vernacular buildings that enclose it on all sides. The south-western side of the square is dominated by Prebendal House, which is set back within substantial grounds and separated from the churchyard by a high brick boundary wall. William Mead, a London merchant, originally constructed the building in the early eighteenth century. It was purchased by the politician John Wilkes who, during the 1750s, remodelled the house in keeping with the Palladian tastes of the day. During the nineteenth century the building was radically remodelled by

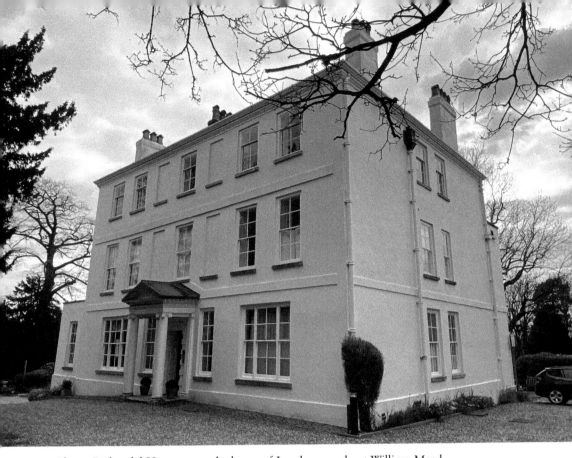

Above: Prebendal House, once the home of London merchant William Mead.

Below: Prebendal House was also once the residence for John Wilkes.

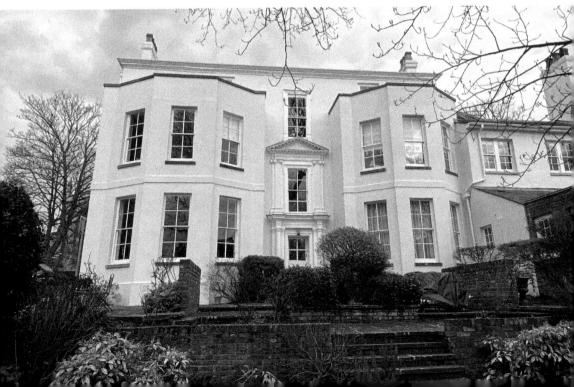

Thomas Tindell, who inserted an additional floor and constructed a hipped roof. The principal elevation of the building faces the churchyard although the entrance gate, which consists of an impressive brick archway with keystone set between rusticated brick piers and curved flanking walls, is located off Parson's Fee.

8. Ceely House

Ceely House, now the County Museum, is a typical eighteenth-century town house with several fine features including its brick frontage and doorway along with its internal decor, encasing a notable guildhall structure of the 1470s. The stable block and associated cottages form an integral part of this domestic ensemble, along with the remains of the yards.

The site here is a key part of the town's historic core and has one of the largest surviving gardens in the town and has strong associations with local notables who lived in Ceely House from as early as the sixteenth century.

The area of Aylesbury that surrounds nearby St Mary's Church has been occupied since the Iron Age when it lay within a pre-Roman Hill fort. An important Saxon minster church was founded near the site of the present St Mary's medieval church in the thirteenth and early fourteenth centuries. A large part of the hilltop, including the site of Ceely House to the east, was occupied by a religious foundation linked to the minster church. The land remained as open

Church Street, where many fine buildings are found, with Ceely House on the right-hand side and the Chantry opposite.

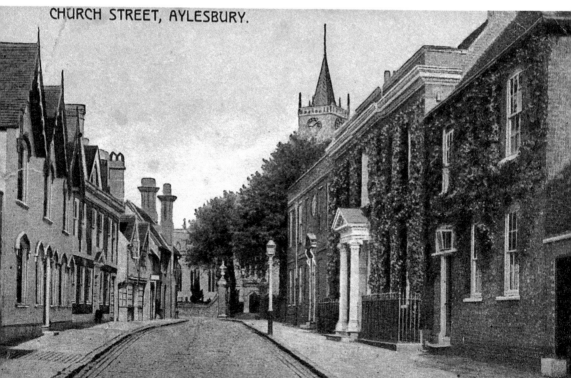

CHURCH STREET, AYLESBURY.

sacred ground for several centuries and was used for Christian burials, likely including people from a wider area beyond Aylesbury.

Sometime around 1473 the medieval Guildhall, known as the Brother House of the Fraternity of the Virgin Mary (a pious lay charitable organisation, founded in 1450), was built. This civic building was encased in the Georgian red brick of Ceely House. The Guildhall was a richly decorated building of high status that was used for meetings and ceremonies. Following the Dissolution of the Monasteries, in 1547 the fraternity was dissolved and the Guildhall became a private house. The occupants were from a line of substantial local families who were church lawyers in the Archdeaconry Court of Buckingham. A fireplace and chimney were installed. In 1598, the grammar school was founded by Sir Henry Lee of Quarrendon in a small chapel at the south-east corner of St Mary's Church. Later in the seventeenth century Richard Heywood made substantial alterations to the building. In 1720, the new grammar school opened adjacent. It faced west onto the churchyard and was flanked by two master's houses. The headmaster's house, incorporating older houses, fronted Church Street adjacent to the former Guildhall.

In the 1750s the front of Ceely House was Georgianised and the timber frame was encased in brickwork and a jetty underbuilt in brick by Aylesbury lawyer Hugh Barker Bell. Much of the medieval rear wing was replaced. There is no record of the garden being developed but a garden was apparently present, presumably

The fine portico of unfluted Corinthian columns with an enriched entablature may have been imported.

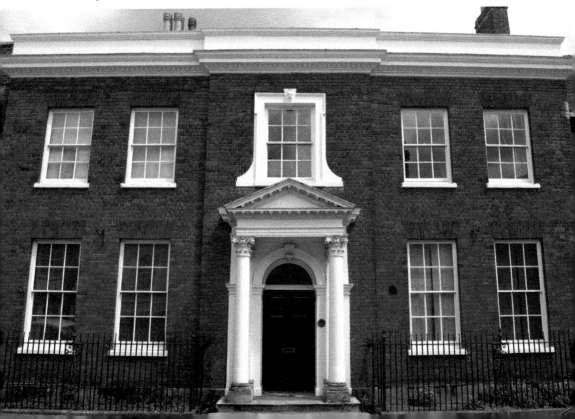

incorporating a former yard that accompanied the Guildhall. The work was carried out for Hugh Barker Bell (second-generation registrar to Archdeaconry Court), who married wealthy widow Mary Thornbury in 1755 or 1756. It was probably her money that paid for the building work at the rear of the house, which included the room that is now known as the 'Baker Room' with its fine plaster ceiling. The coach house was probably constructed at this time as the same brick was used. The brick extension adjoining the house to the south-east was built in 1796 as offices for the registrar. The gate piers, service buildings and cottage were built around 1800. A plan of the grammar school in 1852 shows a walled courtyard garden (in 1907 a new parish hall was built in the garden) directly north of the school buildings and indicates the owner of Ceely House was Joseph Rose.

In 1866, James Henry Ceeley bought the house and thereafter it became known as Ceely House. His brother, Dr Robert Ceeley, Fellow of the Royal College of Surgeons, also lived there and was involved in establishing the Bucks Royal Infirmary (now the Royal Bucks Hospital) in 1833. By 1901 Ceely House was the family home, surgery and dispensary of Dr John Baker. Dr Baker died in 1924. His daughter, Cicely, continued to live there. In 1944, the house was sold to the Buckinghamshire Archaeological Society (BAS). Cicely remained in residence on the first floor until 1950. Baker had joined the Archaeological Society in 1903 and in 1906 was appointed honorary curator of their museum. In 1952, Ceely House was extended and renovated when four gold Edward IV coins struck

Ceely House and the former Free Grammar School to the left.

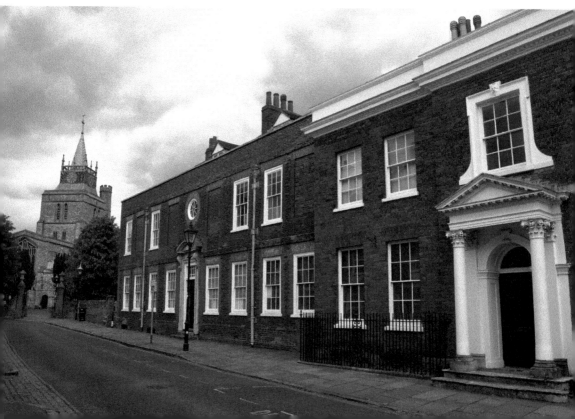

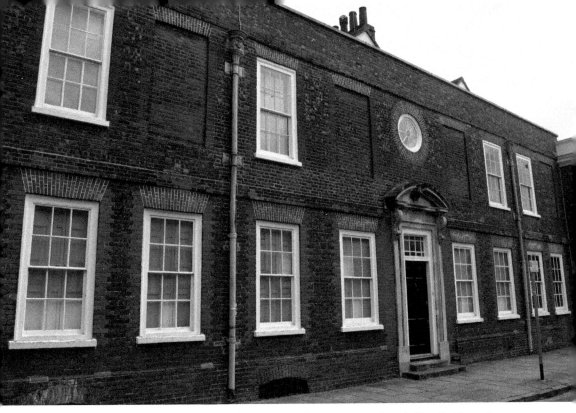

Aylesbury's Free Grammar School, adjacent to Ceely House, was founded by Sir Henry Lee of Quarrendon in the late sixteenth century. The bequest of £5,000 in the will of Henry Phillips, a native of Aylesbury who died in London in 1714, provided for a new school and master's house, built in 1719. The building ceased to be a school in 1907 and is now part of the county museum.

between 1469 and 1470 were found. In 1957, the former grammar school and Ceely House were leased to BAS and Bucks County Council, which operated it as the Buckinghamshire County Museum. In 1989, the museum closed for six years for a £4 million refurbishment and an art gallery costing £0.5 million was built in the central courtyard (of the former school). It was reopened in 1995. In 1996, the Roald Dahl Gallery opened in the former coach house with a major extension to the rear. The County Museum became a charitable trust in August 2014. The site remains in use as the museum garden. The garden has remained largely unchanged in the last 150 years, being subject to a few modifications and additions including the motor house in 2005 and Roald Dahl Gallery attached to the former stable.

9. Friends Meeting House, Rickford's Hill

The town of Aylesbury is recorded as having a designated place of meeting for Quakers in 1686, there having been many homes in which meetings took place during a period of persecution. By the start of the eighteenth century there was a need for a larger meeting place and in 1704 two cottages were

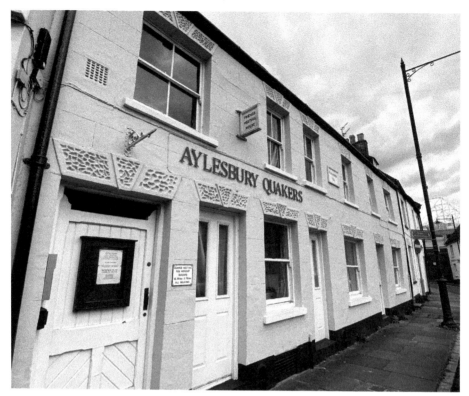

Aylesbury Quakers, Friends Meeting House.

purchased by Friends in Green End, later renamed Rickford's Hill after a resident MP of the 1830s. Friends raised funds and bought the land behind the cottages for a burial place and also built the current meeting house in 1726. In 1836, Quaker meetings stopped in Aylesbury as membership of the society declined with the rise of the evangelical churches. The meeting house was used over the next century for a variety of purposes including a school, commercial premises and a YMCA. In 1878, it was a Baptist chapel.

On 31 October 1933 the meeting house was again registered as a place of worship. Renovation of the meeting house was needed as it had been unused for many years. Since then the site has been a place of worship for Aylesbury Quakers and a focus of service to the community.

10. County Hall (and Assizes Courts)

Aylesbury has many public buildings that reflect its position as the county town of Buckinghamshire, a position it has held since Henry VIII transferred the status from Buckingham the sixteenth century. Legend states it was a move to impress Anne Boleyn's father, who held the manor at the time, but this is probably fictional. As a

county town it was the seat of the former Buckinghamshire County Council, now Buckinghamshire Council after local government reorganisation in 2020. It was also the home of the local assizes today known as the Crown Court. Thus, the town has always had a structure known as County Hall; today the building known by that name houses merely the offices of the former county council. In previous centuries it housed not only the administrative offices of the county, but also the county court chamber, where crimes such as murder, treason and those felonies too serious for a small town magistrate's court were tried. In addition, the County Hall often had an assembly room where entertainments and balls would take place for the more worthy members of the county and their families. Thus, in the eighteenth century County Hall was a reflection of county prestige.

In the early eighteenth century the elders of Aylesbury decided to build a grand and magnificent new County Hall. Plans were submitted by two architects – Mr Brandon and Thomas Harris. The successful plan was to be selected by no lesser architect than Sir John Vanbrugh, architect of Blenheim Palace and Castle Howard. Thus, for a fraction of the price of employing him, Aylesbury had the great man forever associated with the design of its County Hall. In truth if the provincial architect, Harris, intended to flatter Vanbrugh he failed miserably, as the plan Vanbrugh selected was more in the style of his predecessor and rival, the great Sir Christopher Wren. But no matter to the elders of Aylesbury, they had a fine building associated with a national figure.

The building was finally completed in 1740. Despite its lack of an illustrious architect, it is a handsome red-brick building of seven bays and two storeys. The whole style of the building is Palladian with some baroque influences. One

The eighteenth-century County Hall from the Market Square.

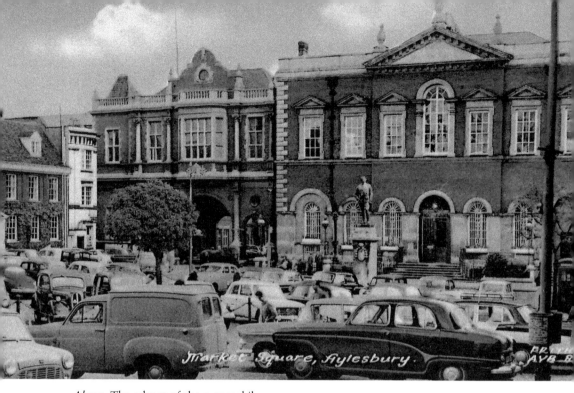

Above: The advent of the automobile.

Below: The County Hall today.

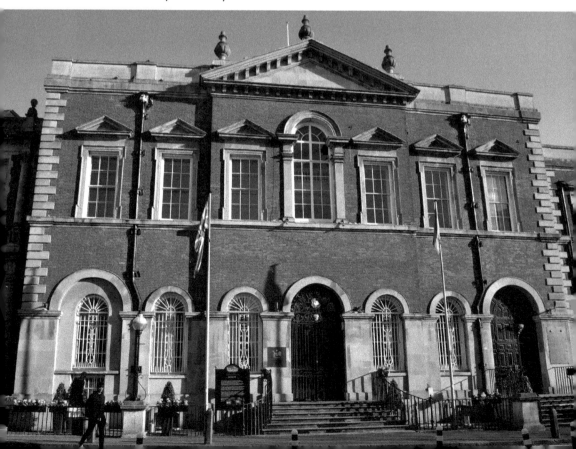

Above: The former Judge's Lodgings.

Below: Built between 1849 and 1850, the former Judge's Lodgings.

feature on the principal façade shows the building's provincial pedigree; Vanbrugh or Wren would have left the façade undecorated or the windows interspersed by pilasters. Here in rural Aylesbury the architect chose to place a humble drainpipe symmetrically between the windows. In London, plumbing was discrete or hidden. The interior contained a panelled courtroom and a council chamber.

Almost from the moment of the building's completion, the eighteenth-century County Hall was not large enough. As local government became more complex and bureaucratic more office space was required and so judge's lodgings were constructed in 1849–50 on the back of County Hall. Following the Local Government Act of 1888 the newly established Buckinghamshire County Council based itself here, hence further council rooms, including a mayor's parlour, were added too.

11. Ye Olde Harrow Inn

For over a hundred years there has been a public house on the site – at times even two. Most famously, to the locals back in the days before cars existed, there was The Harrow and next door was The Barleycorn. Later, in 1982, the pubs were merged and renamed, unsurprisingly, The Harrow & Barleycorn. Later renamed the Farmyard and Firkin, more recently in 2004 it was renovated and renamed The Harrow. First registered licensee is recorded as Mr Thomas Clinton in 1753. All the names of the pubs on this site relate back to the seventeenth century when the buildings were believed to be part of the old farmhouse of the ancient manor of Aylesbury.

Now known as 'The Harrow'.

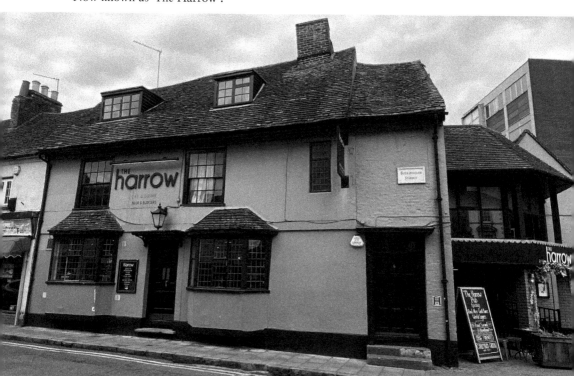

12. Ardenham House

Ardenham House is one of Aylesbury's most important late Georgian houses by virtue of it being one of the few buildings in the town accredited to a notable designer, albeit a sculptor rather than an architect. Joseph Nollekens is said to have designed this large neoclassical house for his sister-in-law, 'Miss Welch'. The daughter of Justice Saunders, Welch (a friend of both Samuel Johnson and William Hogarth) Nollekens had married her younger sister Mary in 1772. This means the house can be no earlier than this date. Miss Welch is reported to have been a great intellectual, using Ardenham House as a literary salon. The large square red-bricked edifice is of a simple design – a three-bayed front of three floors. The severity of the façade is only alleviated by a porch with Tuscan columns. The design of this façade is typical of the simpler neoclassical approach to architecture of the late eighteenth century.

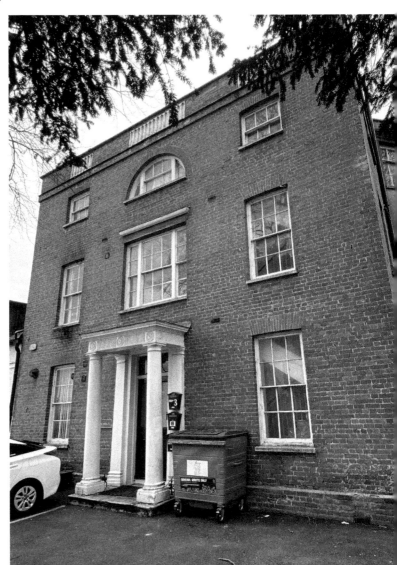

Ardenham House, with a connection to a famous sculptor.

Ardenham House – late Georgian in style.

13. St Osyth's

The former vicarage, now called St Osyth's, adjoins the Prebendal House on Parson's Fee. The prebendary, or parson as he was sometimes known, had the right to collect a tenth – or 'tithe' – of the crops of other farmers in the parish. At the enclosure of Aylesbury in 1772 the prebendary received a 272-acre allotment of land either side of the Oxford Road in lieu of his right to collect tithes. The vicarage house appears to have been used as the farmhouse for this land until a new Prebendal Farm was built beside the Oxford Road in the mid-nineteenth century. It eventually served at times as a home for assistant clergy, either for a man with a family or shared by bachelor curates. The house was restored in the 1950s and rearranged inside, but the exterior remains much as it was. Behind the house is a large barn of six bays – probably the late sixteenth-century tithe barn.

So where does the name St Osyth originate from? St Osyth was born in the now deserted village of Quarrendon, near Aylesbury, into the royal family of Mercia in the seventh century. Though a granddaughter of King Penda, a pagan, she was sent to a convent in Warwickshire to be educated, an experience that left Osyth

determined to become a nun. Duty, or forceful persuasion by her father Frithwald, saw her married nevertheless to King Sighere of Essex, with whom she had a child. But her religious ambition remained and she eventually established a nunnery in Essex. She is said to have been slaughtered by marauding Vikings who executed her by beheading.

As her convent was in Essex it seems likely she met her end there, but her legend has her brutal murder happening in the place where she was born, Quarrendon. And the story goes that after the Vikings decapitated her, Osyth leant down, picked up her bloody head and, to the astonishment of her Viking assassins, carried it to the doors of a nearby religious foundation, where she finally expired. A holy well is supposed to have begun flowing pure water at the moment and site of her death. Several places around Aylesbury dispute this highly doubtful prize, including Quarrendon itself on the town's north-west edge, and the village of Bierton a few miles north-east. But what a fabulous tale.

St Osyth's – one of the most significant buildings in Aylesbury.

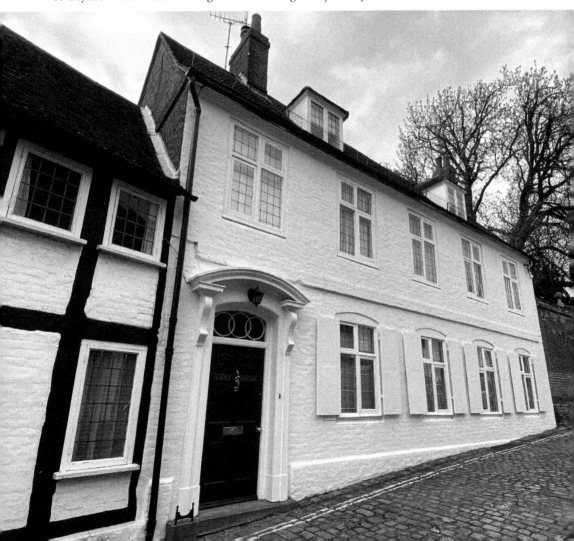

14. The Green Man

The Green Man was once one of Aylesbury's most popular public houses, and during the 1970s was frequented by the likes of Joe Strummer from The Clash and Lemmy from Motorhead after gigs at the nearby Friars. The Green Man is an early nineteenth-century stuccoed building of three storeys and a cellar. Of particular note is the balcony running across the whole of the front elevation at first-floor level, which has a cast-iron balustrade attractively decorated with honeysuckle patterns. Today it is empty like a number of Aylesbury's most noted public houses.

Adjacent to this is the Barclays bank building, which is early eighteenth century in date and has a much wider principal elevation. Constructed of red brick, it is two storeys plus an attic and sits on a projecting stuccoed stone plinth.

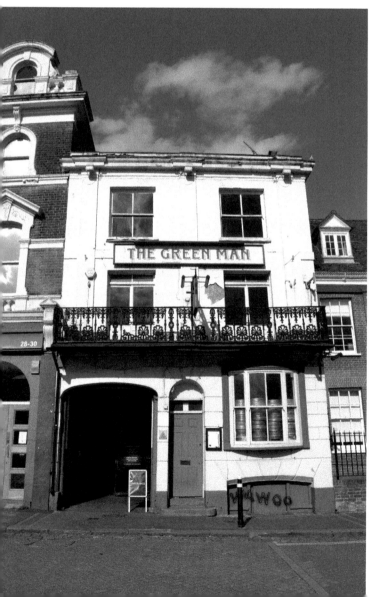

The Green Man, overlooking Market Square. Once a drinking haven for the many bands that played at the Friars.

An early eighteenth-century building.

15. Walton Terrace and Walton Lodge

Walton is situated to the south-east of the historic centre of Aylesbury. It was originally a distinct hamlet separated in part by a stream called the Bear Brook. Significant archaeological evidence has been found for Saxon settlement at Walton, even though no documentary reference for the village survives prior to AD 1090. The topography of Walton has not altered greatly since the Middle Ages, with almost all the historic structures still fronting onto the two main thoroughfares of Walton Street and Walton Road. In 1651, the site of the manor at Walton abutted the village green, but the enclosure map shows that by 1800 this area had been significantly reduced, and now all that remains is an area of open space around the village pond and another open area at the north of Walton Green Road, now occupied by a car park.

Walton Street is now a busy vehicular route from the centre of Aylesbury south-eastwards to Wendover and south-westwards to Stoke Mandeville. During the mid- to late eighteenth century Walton Street was turnpiked and the carriageway was lowered, resulting in a raised pavement that still exists in front of Walton Terrace. The majority of the historic buildings that form Walton Terrace are situated back from the raised pavement behind shallow front gardens bounded by walls and railings. The buildings themselves form an irregular group of seemingly

Georgian and early nineteenth-century buildings of varying heights, elevation widths, designs and positions within their plots.

Buildings of note in Walton Terrace include the late eighteenth- and nineteenth-century elevations of Nos 3 (Rosebank) and No.9. The latter's most striking feature is the wooden veranda with its elegant balustrade and concave lead roof that extends across the ground floor. It is an impressively fronted building reminiscent of the Spanish colonial style. This house was in the ownership of the same medical family for over 200 years.

The most visually prominent building within the terrace is Walton Lodge, which is a substantial early nineteenth-century property situated slightly back from the pavement within sizeable grounds. Attention is drawn to the building because of its size and the restrained form of its architectural detailing such as the heavy rusticated stone entrance porch.

The Spanish colonial style of one of the properties on Walton Terrace.

Walton Lodge, dating from the early nineteenth century.

16. Rickford's Hill

Rickford's Hill runs downhill from the south-western corner of Temple Square to Friarage Road. The street was originally called Pitches Hill but was renamed after William Rickford, who lived in Greenend House between 1795 and 1855. He founded the Old Bank, now Lloyds, in the Market Square and was a leading figure in the town.

For the majority of its length Rickford's Hill is quite narrow, but it opens out at the junction with Bourbon Street before narrowing again in its final descent to Friarage Road. The north-eastern section of the street, close to Temple Square, is lined by historic buildings situated up to the back of the pavement, which creates a strong sense of enclosure and channels views.

The historic buildings situated along Rickford's Hill vary in form and appearance. Particularly fine buildings include No. 1 Rickford's Hill, which is situated on the eastern side of the road and is a two-and-a-half-storey, late seventeenth-century building with an altered front. The building is constructed of vitreous brick with red quoins and window surrounds, and presents a very regular and symmetrical principal elevation to the street. The most substantial and possibly the finest building situated along Rickford's Hill is No. 10, Greenend House.

Adjacent to Greenend House is No. 12 Rickford's Hill, which is a two-and-a-half-storey building with a handsome early eighteenth-century principal elevation. To the north-east of Greenend House, separated from it by a carriage way entrance, are Nos 2–8 Rickford's Hill. No. 8 is late eighteenth century in date and originally served as an annex to Greenend House.

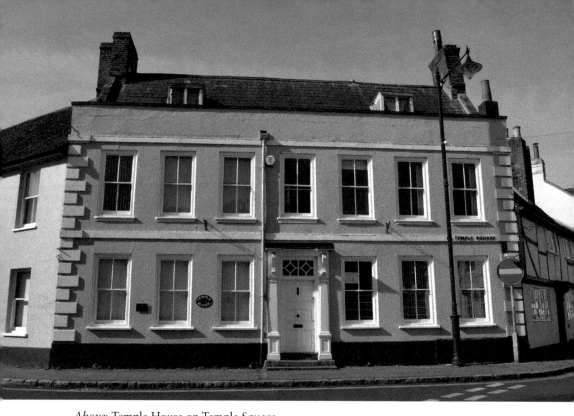

Above: Temple House on Temple Square.

Below: No. 1 Rickford's Hill.

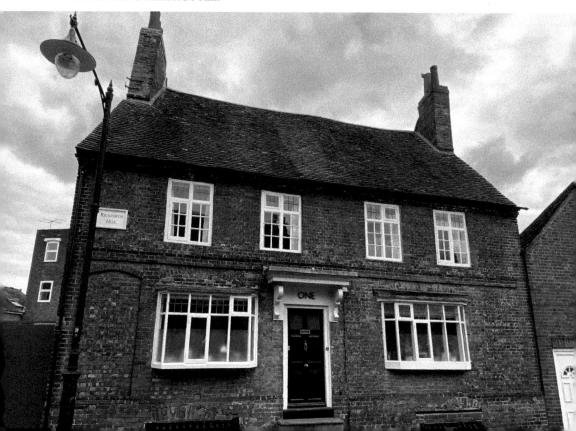

17. Hills & Partridge Flour Mill

Hills & Partridge (behind Tesco) was the last flour mill in Aylesbury, closing in the 1990s. There is very little left of the building complex today. Grade II listed by Historic England as Walton Mill House, it is dated by bricks with the initials 'TW' and 'RF' on the front elevation, from 1800.

The building incorporates a fragment of an early sixteenth-century building with an L-shaped main building to the south and one-storey early nineteenth-century addition to the north.

The remains of the former Hills & Partridge flour mill – Grade II listed.

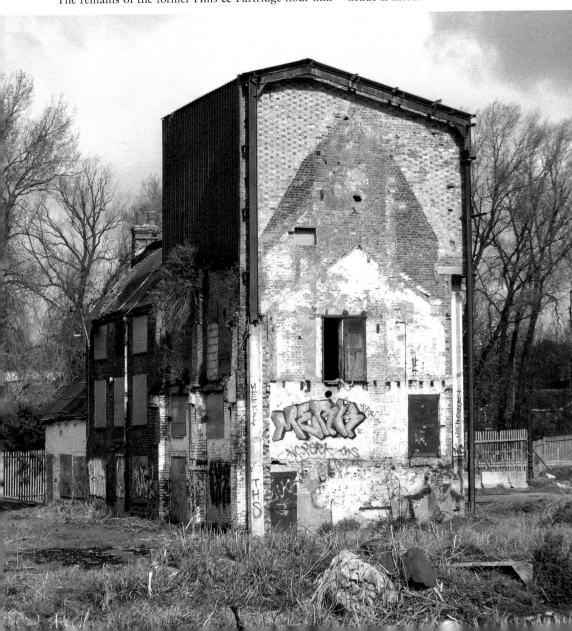

18. Former New Inn, Wendover Road (now Broad Leys)

The former New Inn on Wendover Road was later renamed Broad Leys. It was alongside this inn that all traffic from Tring came in to join the Wendover Road for access to Aylesbury, as before 1826 when the High Street was built there was no other direct route into Aylesbury from Tring. On the 1799 map of Walton the road is shown cutting across Turnfurlong to join the Wendover Road and thence up to Walton Street into Aylesbury. The pond now in front of the adjacent police headquarters is very small compared to its size in 1799, when it is shown approximately five times the size of Walton Road, in front of Harding's house in Walton Road.

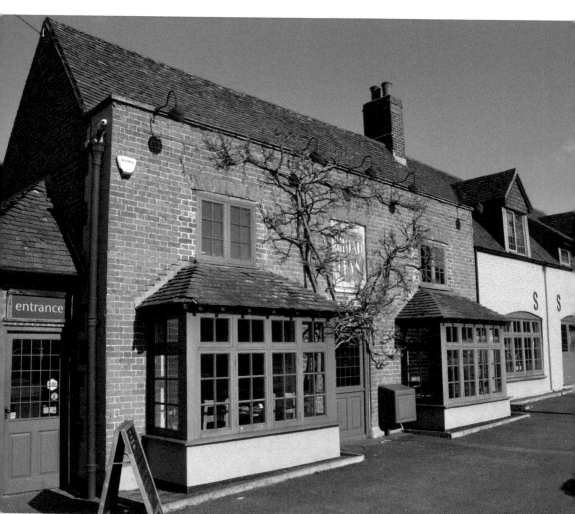

The Broad Leys, once known as the New Inn.

19. Former Workhouse and Tindal Centre

The 1725 edition of *An Account of Several Workhouses* mentions the existence of parish workhouses in 'Ailesbury, Asheton Clenton and Wingrave'. A Parliamentary report of 1777 recorded parish workhouses in operation in Aylesbury with accommodation for up to ninety inmates, and at Wingrove for twenty inmates. Aylesbury's first parish workhouse was in St Mary's Square at the north-east corner of, and opening into, the churchyard. According to Gibbs (1885), 'The inmates of the Workhouse were a heterogeneous family, paupers, pauper lunatics, idiots, imbeciles, infirm, aged, impotent, wayfarers, orphans, and the children of many fathers were all huddled together.' Gibbs goes on to describe 'classification, excepting in the male and female dormitories, could be but feebly carried out; the inmates were allowed to wander wherever they pleased during the day, but were generally found at hand at meal times. The original idea of work for which the house was at first intended had long been discarded, and nothing left of it but the name'.

In 1758, the workhouse is mentioned in the parish vestry minutes when it was resolved that 'under no pretence whatever, should the overseers pay or cause to be paid any sum or sums of money for the relief of persons who refuse to come into the workhouse, and that after Michaelmas no rents will be paid or allowed'. By the 1780s the operation of the workhouse was being contracted out under the 'farming' procedure. Tenders were taken from interested parties who were prepared to undertake the board, clothing and general management of the workhouse at so much per head per week. In 1781, William Foreman agreed to maintain the poor of the parish for the sum of £669 for a period of one year. In 1825, the contract was for 4s 6d per head per week. If the price of food rose unexpectedly, the contractor might be paid extra to cover this. Specific provision was occasionally also made for children in the workhouse. At one time twelve catechism books were bought; at another, payments for schooling only for boys were made at a rate of 2d per boy per week. The churchyard frontage of the workhouse building was later converted into cottages and the rear occupied by British School Buildings.

Overcrowding of the St Mary's Square workhouse led to the erection of a new, larger workhouse in 1829. Mr Rickford donated 2 acres of land for the new building on Oxford Road on the site of what is now Mount Street and St Mary's School. Aylesbury Poor Law Union officially came into existence on 6 July 1835. Its operation was overseen by an elected board of guardians.

The population falling within the union at the 1831 census had been 21,480, with parishes ranging in size from Creslow (population of five) to Aylesbury itself (5,021). Initially, the new union decided to continue using the recently erected Aylesbury parish workhouse. However, within a few years this proved inadequate, and a new union workhouse was built in 1844 on Bierton Road in Aylesbury. It was designed by architect S. O. Foden in collaboration with Assistant Poor

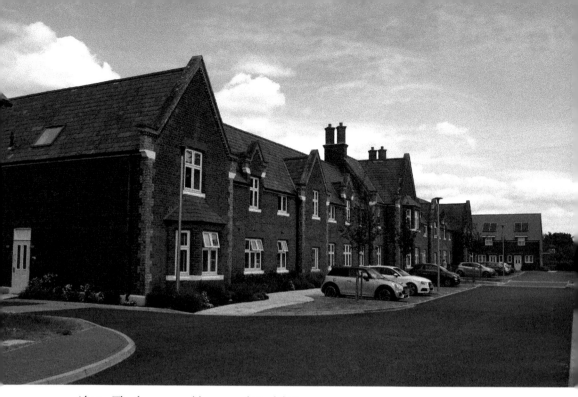

Above: The former workhouse and Tindal Centre.

Below: The former porter's lodge and guardians boardroom.

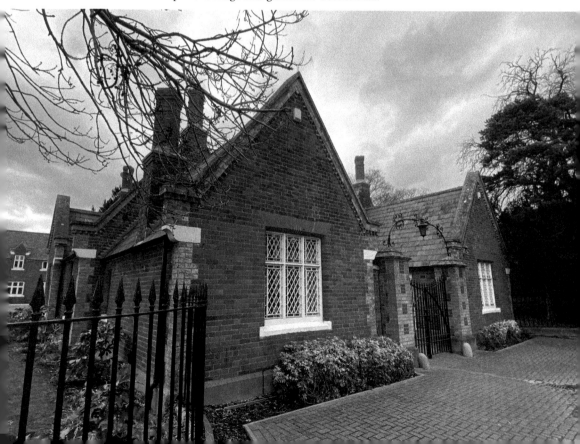

Law Commissioner H.W. Parker. Foden was the architect of a number of other workhouses across the country. There were two small blocks at the entrance to the site. One was a porter's lodge with an adjoining waiting room. The other housed the guardians' boardroom.

A separate infirmary block was later added at the north of the workhouse where the casual ward, stables and various utility blocks were also located. By 1925 it was officially known as Aylesbury Poor Law Institution.

From 1904, to protect them from disadvantage in later life, the birth certificates for those born in the workhouse gave its address as No. 100 Bierton Hill, Aylesbury. During the Second World War the former workhouse became Tindal Hospital and a large annexe of Emergency Medical Scheme huts were erected on the site to cope with evacuations from London's Middlesex Hospital. In more recent times, the main block and lodge buildings became home to a mental health facility called the Tindal Centre, which closed in 2014. Today it has been converted into residential properties.

2c. Former Horse & Jockey Public House (now The Aristocrat)

The former Horse & Jockey public house at Nos 1–3 Wendover Road is one of Aylesbury's oldest public houses. The pub door opened into a very small lobby, with doors leading off into small bars on either side. Much of the ground floor was living accommodation and beer storage. The cellar was also very small and appeared permanently wet. Upstairs were two attic bedrooms and one chamber.

The former Horse and Jockey public house, one of Aylesbury's oldest pubs.

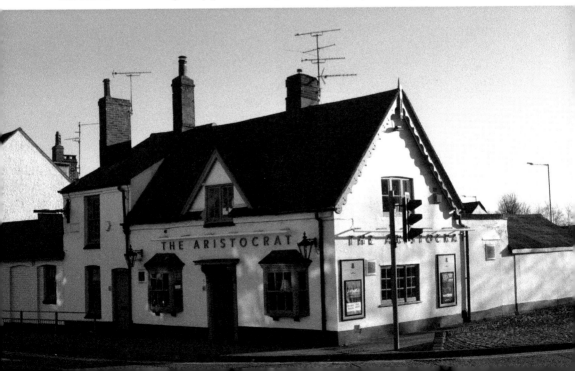

The two bay windows were late Victorian additions. The Horse & Jockey, in the first half of the nineteenth century, was kept by Mr Beechey and was known as Beechey's Beerhouse. Mr Beechey also dealt and traded horses.

21. Holy Trinity Church, Walton Street and Adjacent Vicarage

The site of this imposing church was given by Revd Hollond of Saxmundham, Suffolk, who also contributed handsomely to the building costs. The original Holy Trinity building dates to 1844, as an expansion of the congregation at St Mary's – the ancient town centre church. The new church was located in what was then the village of Walton, just half a mile away. The early Holy Trinity had an emphasis on worship, particularly hymn singing. The new building soon proved too small and various enlargements took place: a gallery in 1895 followed by a baptistery, porch and tower with three bells in 1886–87. It was consecrated on 30 May 1845 by Dr Kaye Robert Gibbs.

This early congregation was largely poor, being mainly drawn from the boat people of the canal and the families of the famous Aylesbury duck herders. In 1859, a friend of the vicar of Holy Trinity loaned money to buy two cottages next to the church to start what was to become Walton Holy Trinity National School (now Walton Hall) to support and educate local children. Walton Hall has been a focus of local community life from this time ever since.

Holy Trinity Church on Walton Street.

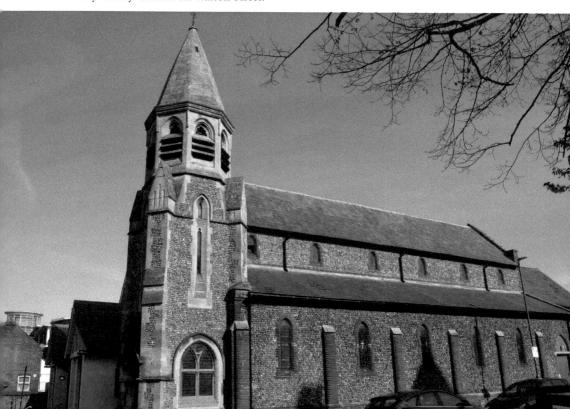

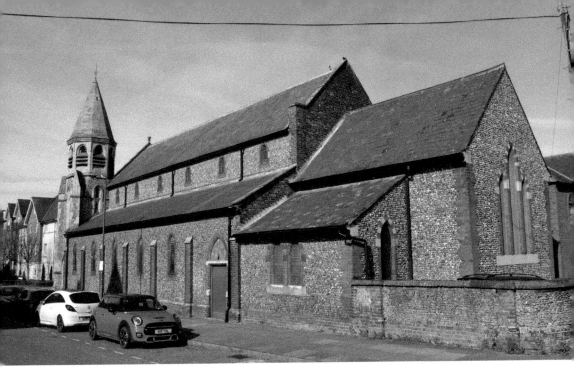

Above: Holy Trinity once served some of the poorest residents of Aylesbury.

Right: Holy Trinity Church, which was consecrated in 1845.

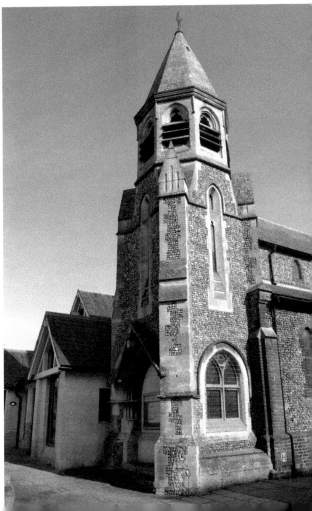

The ecclesiastical census of 1851 records a combined morning and evening congregation of 732. Electric light was added in 1919. The church continued to grow and expand throughout the last century. A new congregation and junior church were started in the Tring Road County Primary School in 1952 (later to become the Church of the Holy Spirit, Bedgrove). Another daughter church, the Church of the Good Shepherd, Southcourt, was erected in 1956.

The adjacent former vicarage to Holy Trinity Church – always an expensive building for a vicar of limited resources to heat.

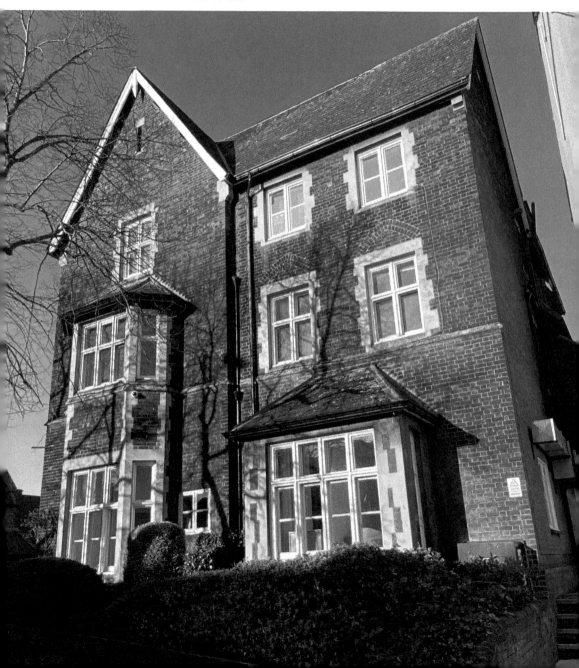

The vicarage is a huge red-brick building, designed by Mr Brandon of Berkeley Square, London, and was built in 1862. It was a building that no vicar could ever afford to heat. It had extensive gardens running back 140 yards down Parrotts Alley. One tale often told is that early one morning the vicar returned from a night visit to one of his parishioners as the charlady was scrubbing the steps. As he went in he addressed her: 'Winter draws on Mrs Mop,' to which she replied sharply, 'and so would you if you had to scrub these steps at 7:30 of a winter's morning!'

22. The Bell Hotel

One of the most prominent public houses in Aylesbury, The Bell, is a Grade II listed building that has an early to mid-nineteenth-century façade. The third floor (with dormer windows) was added in 1919. Remains of large internal beams, discovered during recent renovations, indicate that the building dates from medieval times. The Bell was mentioned in the fifteenth century, when Market Square had several inns or taverns.

The Market Square began hosting weekly markets as early as the eleventh century and made Aylesbury the focal point for the surrounding villages. By the 1300s large market fairs were held twice a year, with people travelling from all over the county to buy and sell goods.

The Bell Hotel in the corner of the Market Square.

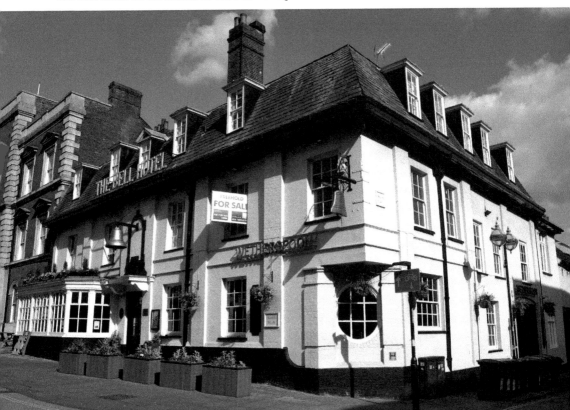

By the nineteenth century, and with the opening in 1865 of the Corn Exchange, Aylesbury had forged a historic reputation as a leading market town. Every Saturday the square was packed with all manner of agricultural produce. The cobbled streets were laid with straw for the sale of cattle, pigs and poultry. In addition to the regular markets, specialist horse fairs were held outside The Bell on six Saturdays a year.

By the beginning of the twentieth century the sale of animals in Market Square had dwindled due to the council opening an official livestock market. The new location, which had direct access from Exchange Street, made it much easier for the delivery and collection of animals.

As the square changed so did The Bell, as it underwent restoration and an extension in 1919. The alterations provided an extra storey and created accommodation at the rear with an angled entrance on the Walton Street corner.

23. HMP Aylesbury

There has been a prison or gaol in Aylesbury since 1810, with the current prison being present here since 1847. It is an early Victorian design and was apparently modelled on the county gaol in Reading, Berkshire. The site chosen was in an area of public buildings that also included Aylesbury's workhouse and the Manor House Hospital.

The prison gate is flanked by the governor's house to the east and the chaplain's to the west. Above the gate is the date '1845' on a frieze that was designed by

HMP Aylesbury, once the scene of hunger strikes and hangings.

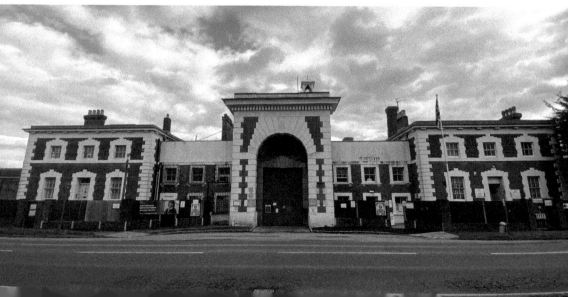

architect Charles James Pierce and Major J. Jebb. The central arch is impressive, with a massive, rusticated doorway and a portcullis motif in the tympanum, and a small wooden bell turret to the roof. The prison chapel had 274 seats arranged so that prisoners could see the clergyman but could not each other. Since construction, the prison has gone through a number of changes, starting as a county gaol then became an adult women's prison in 1890, changing to a girls' borstal in the 1930s. Between 1959 and 1961 it was an adult male prison, after which it became a male youth offenders institution, and since 1989 has held only male long-term prisoners.

Aylesbury Gaol holds a significant place in the campaign for women's suffrage. It housed a number of suffragette prisoners arrested during mass demonstrations by the Women's Social and Political Union (WSPU), a militant suffrage organisation whose members used direct action in support of their campaign for the vote. In March 1912, suffragettes carried out a mass window-smashing raid in London. Holloway Gaol, the usual prison for suffragettes, could not cope with the numbers arrested, so many were sent to Aylesbury. On 5 April, the prisoners began a secret hunger strike, which went undetected for several days. When the authorities found out, hunger strikers were fed by force, although four were released on health grounds.

The Aylesbury hunger strike spread to other prisons, becoming the largest mass hunger strike undertaken by suffragettes, with over eighty prisoners taking part. Aylesbury became the focus for protests against forcible feeding, and on 13 April 1912 over 100 protesters marched on the gaol to hold a meeting at the gates. Suffragette prisoners waved handkerchiefs from their cell windows. Suffragette Violet Bland, who was also force fed, wrote a book when she was released entitled *Votes for Women*, which told of the experiences she had while incarcerated.

The prison has also been the witness to a number of grisly public executions. Over the main archway was a drop mechanism for hangings. On 24 March 1854, the first execution at the drop was of a man called Moses Hatto, who committed murder at Burnham Abbey. The last public execution held here was in 1864.

24. The Old Aylesbury Bank

The Old Aylesbury Bank was founded in 1795 by a local entrepreneur William Rickford and was for many years the only banking establishment in the town. The quality of the bank's architecture is a good barometer of the wealth that came from being the sole financial depository within a large rural area. The building dates from 1853. It seems that the highly fashionable Gothic Revival style had not yet reached Aylesbury, as the owners of the bank selected an Italianate classical style. The ground floor is rusticated but the blocks of ashlar are imitation, as is the quoining on the floors above.

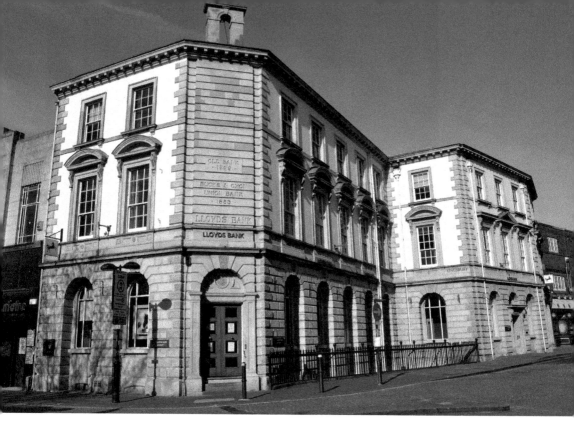

Above: One of the most prominent buildings in the Market Square is the Old Aylesbury Bank.

Left: Now Lloyds Bank.

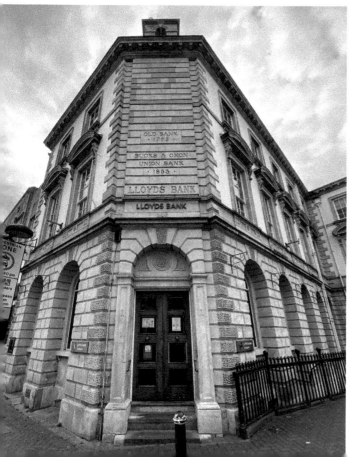

The bank standing on the junction of Market Square and Kingsbury Square has a canted façade in order to suit the triangular junction caused by the meeting of the two squares and a common street. The building in style is very reminiscent of those buildings of architects Thomas Cubitt and Edward Blore in London at this period. The possibility of a notable architect is likely as in nearby Leighton Buzzard the great Gothic Revival architect Alfred Waterhouse was commissioned to design an equally small provincial bank (now Barclays) in the town's High Street – there was great rivalry between the small rural banks. The appearance of the bank itself was seen not only as a sign of prestige, but also financial security, both evaluated by small local businessmen and farmers when entrusting their money.

25. Aylesbury Cemetery

Aylesbury cemetery on Tring Road was opened in 1858 and was designed by Reading-based architects, W. F. Poulton and Woodman. The architects designed the chapels in the cemetery in a Gothic style, having won the contract in a competition. Specialising in Nonconformist churches, they were successful in competitions for several cemeteries in central southern England. Both chapels are now Grade II listed and are fine examples of early burial board architecture. R. Gibbs describes the chapels in his *History of Aylesbury* as being of 'light and pleasing appearance'.

The Dissenters' Chapel.

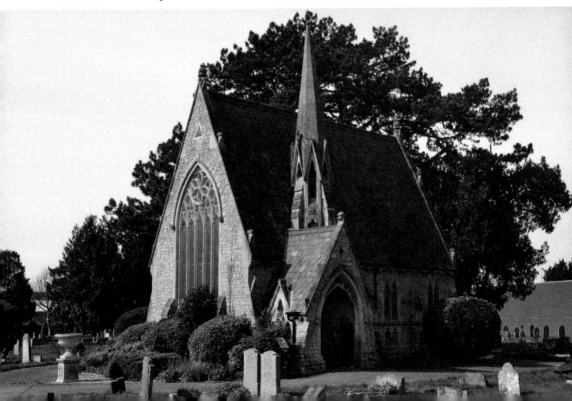

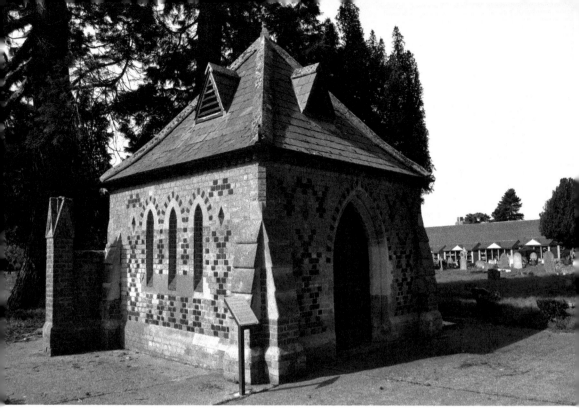

Above: The Dead House is Gothic in style.

Below: The Episcopal Chapel.

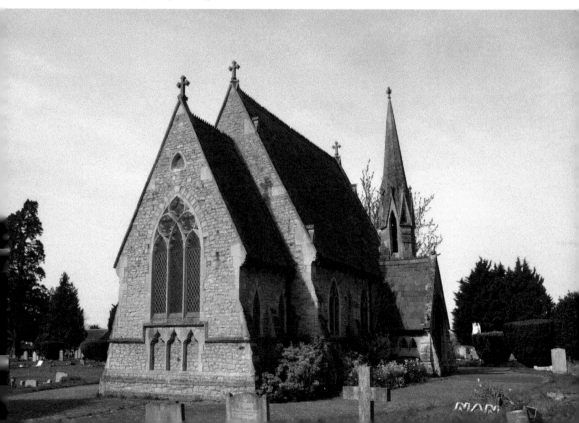

In the Victorian era, dead houses served as mortuaries to house the dead until they could be buried. Before their introduction, the deceased would be laid out in the family home, possibly for weeks, until the burial could be arranged. This led to public health concerns. In cold climates, bodies were kept in dead houses over the winter when the ground was too hard to dig.

A common fear at the time was being buried alive. Some dead houses in Europe served to ensure a person was truly deceased before they were buried. Attendants at the Apparent Dead House in the Hague would use mirrors and feathers to check for breathing. Dead houses were also used to prevent grave robbers taking bodies from graves and selling them for anatomical research. Bodies were kept secure in a dead house until the natural process of decomposition rendered them unsuitable for dissection.

26. Royal Bucks Hospital

In 1832, a group of the local gentry led by Dr Lee of Hartwell formed a committee to start an infirmary. They purchased a large house on the corner of the Bicester and Buckingham Roads and fitted it out as a hospital the following year. Founded in 1833, it was rebuilt as the building we see today in 1861–62 and extended in 1908, and many times since then. The Royal Bucks is now a private hospital. It was originally an eighteenth-century house and was remodelled as a

The former Royal Bucks Hospital.

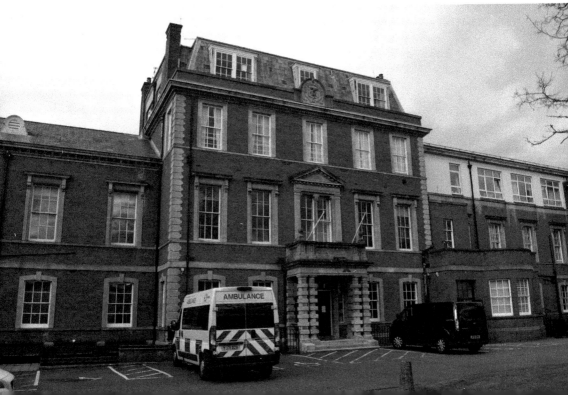

hospital when new wings were added to it. Much of the remodelling was done to a design by David Brandon using a pavilion layout, which was heavily influenced by Florence Nightingale through her brother-in-law Sir Harry Verney, who lived at nearby Claydon House. The building is a fine example of one of the first model hospitals built in the country. Florence returned from the Crimea to Claydon House and had seen first-hand the importance of good hygiene, sanitation, light and fresh air as essentials to good healthcare and for those returning to health. Her involvement at the Royal Bucks led her to say, 'It will be the most beautiful hospital in England.'

The hospital became 'Royal' after the Prince of Wales received treatment here in the late nineteenth century. A new wing was commenced in 1905 with a foundation stone laid by Lord Rothschild, completed in 1908.

As Stoke Mandeville hospital expanded nearby, the Royal Bucks Hospital joined the National Health Service as a maternity hospital in 1948. It became a private hospital in 1994 and, after acquisition by Affinity Care Homes and an extensive subsequent refurbishment, it reopened as a facility for the treatment of patients with spinal cord, acquired brain injury and other neurological conditions in 2013.

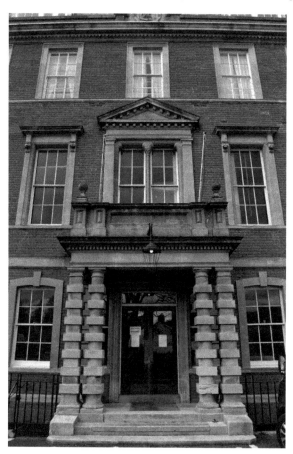

An impressive entrance to the building of the former Royal Bucks Hospital.

27. Aylesbury Railway Station

The first station on the site was opened in 1863 by the Wycombe Railway, which was taken over by the Great Western Railway in 1867. In 1868, the Aylesbury & Buckingham Railway (later part of the Metropolitan Railway) reached Aylesbury.

When opened, the line to Aylesbury from Princes Risborough was broad gauge. To avoid mixed-gauge track when the standard-gauge Aylesbury and Buckingham arrived at the station in 1868, the section to Princes Risborough was converted to standard gauge, and therefore until the rest of the Wycombe Railway was converted in 1870 there was no access to the rest of the GWR system. The GWR provided motive power and trains to both the Wycombe Railway and the Aylesbury & Buckingham, and ran a shuttle service from Princes Risborough to Verney Junction.

A broad-gauge, single-road engine shed was provided from the station's opening in 1863. The shed was doubled in length within a year or two, and in 1870 became a two-road shed with a lean-to added to the east side of the original shed. By 1892, with the arrival of the Metropolitan Railway, the shed was converted to a north-light, two-road shed using the west wall of the original broad-gauge shed and the east wall of the 1870 extension.

The Metropolitan Railway was opened from Chalfont Road in 1892 to a separate station named Aylesbury (Brook Street) adjacent to the GWR station. It closed in 1894 when services were diverted to the GWR station. The Great

Aylesbury railway station.

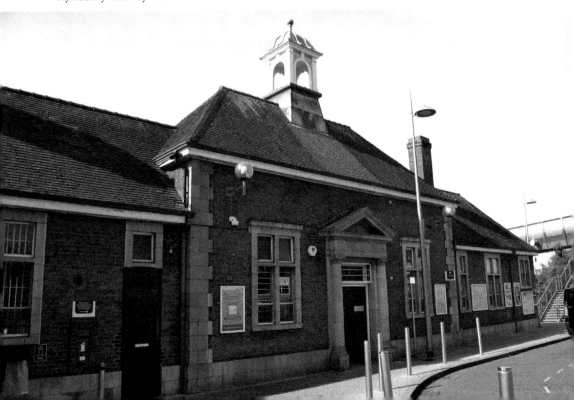

Central Railway reached Aylesbury in 1899 from Annesley Junction, just north of Nottingham on its London extension line to London Marylebone.

The original station had one platform with a brick-built station building and a canopy projected from the building over the platform supported on cast-iron pillars. The cost of the station building was shared between the Wycombe Railway and the Aylesbury & Buckingham Railway; the original plans are in Aylesbury's local records office.

The current station buildings date from 1926, when the station was extensively rebuilt again – this time by the London & North Eastern Railway. Until nationalisation in 1948, Aylesbury station was operated by a joint committee whose constituents were also joint committees: the GWR & GCR Joint and the Metropolitan and GCR Joint. Although the LNER had taken on the role of the former Great Central Railway in all three joint committees, these committees were not renamed.

28. The Corn Exchange

From the beginning of the nineteenth century, most towns in England had a building known as the Corn Exchange. Here, farmers and grain merchants bartered for and fixed the price of grain. In a rural community, where the greatest percentage of the community was directly involved with agriculture, this was a very important building, as here was decided the economy of the district. Often other agricultural commodities such as wool, were traded here. The Corn Exchange was often a grand, imposing building which doubled as a venue for public entertainment such as concerts and plays. The Corn Exchange in Aylesbury is less grand than some of its contemporaries: at nearby Leighton Buzzard the Corn Exchange was an Italianate palace.

The building here was erected by a consortium of local businessmen known as the Aylesbury Market Company with capital of £18,000. They purchased and demolished the White Hart Inn, replacing it with a new cattle market and the Corn Exchange. The site adjoined the County Hall, which conveniently reflected its intended importance in the community. Designed by architect D. Brandon in 1865, the Corn Exchange takes the form of a red-brick tripartite triumphal arch leading to further council offices. Above the arches the reception rooms have large mullioned and transomed windows.

This Jacobethan building sits incongruously in the corner of the Market Square next to the classical county hall and opposite a bow-fronted Regency public house with an ornate entablature. However, this siting of opposing styles of architecture and constant change is the essence of character of an English market town. The agricultural depression that occurred from the 1870s resulted in a steep decline in the value of grain. The Corn Exchange never realised the profits its builders intended and in 1901 it was eventually sold to the Urban District Council as the new Aylesbury Town Hall. The Corn Exchange today houses council conference rooms.

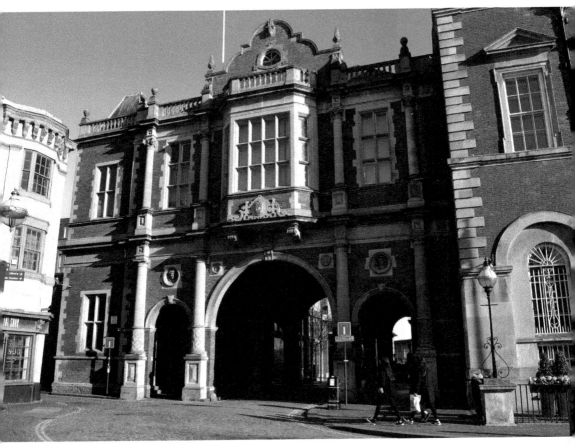

The Corn Exchange, designed by local architect D. Brandon.

29. Former Derby Arms

A Grade II* listed building, the former Derby Arms is a fine-looking, Georgian-style building and was previously used as a private dwelling. Its frontage dates from the eighteenth century and is built with vitreous brick and red-brick quoins and dressings. The building behind the frontage is older.

Although the Derby Arms was licensed in 1866 only, it was adjoining on the site of an earlier malthouse, which had been pulled down in the middle of the nineteenth century, and replaced by two tenements. From 1649 to the early part of the nineteenth century, the property was owned by the Russell family of Aylesbury, who had several other properties in Aylesbury. For part of its history, the site of the public house descended with Bull Close, which was auctioned in lots between 1853 and 1867. The Derby Arms appears to have been purchased by H. & G. Simonds Ltd. in 1937. Today it is wholly residential.

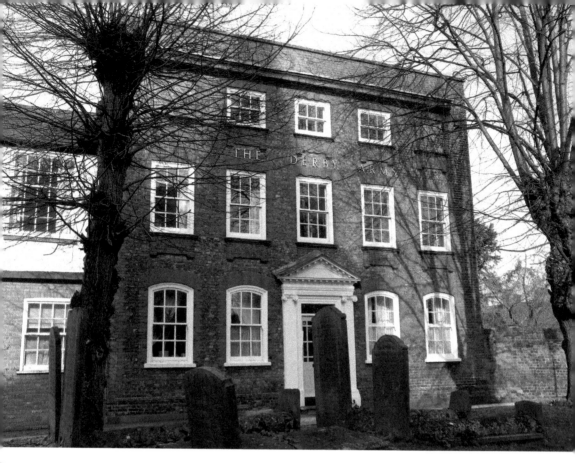

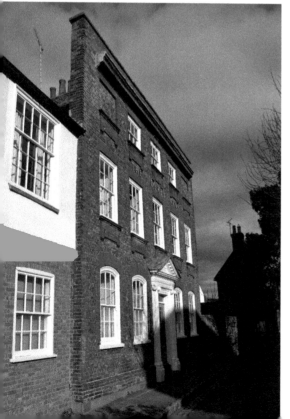

Above: The former Derby Arms on St Mary's Square.

Left: The former Derby Arms and its impressive façade.

30. Former British School, Pebble Lane

The north-eastern side of the street is formed by buildings situated hard up to the back edge of the pavement. The one exception to this is the former British School which is set back from the lane behind a low brick wall topped with metal railings. The building was constructed in 1872 on the site of a former workhouse. It was enlarged in 1885 and provided places for 556 children of Nonconformist families. When it closed in 1907, the children were moved to Queen's Park School. The building then became the Education Sub-Office and for many years the home of the County Library Service. It is a substantial building which presents a gabled elevation to the street. It is constructed of brick laid in a Flemish bond with some decorative vitrified brickwork. Positioned centrally within the gable is a large mullion and transom stone window.

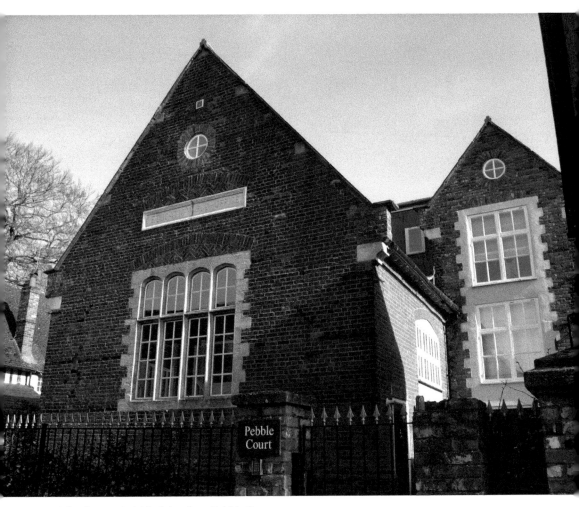

The former British School on Pebble Lane.

31. Former Congregational Church, Hale Leys

The Congregational Church was built in 1874 on the site of the old Independent
Chapel of 1818, which had itself replaced the Presbyterian building of 1707. On
the 1809 map it is just shown as a meeting house. By the late nineteenth century it
appears to be a private house with a reasonable amount of garden in front, with
many of the nearby buildings (originally houses) eventually becoming shops by
building over the gardens. The Congregational Church was demolished, except
for the tower, to make way for the Hale Leys Shopping Centre. The congregation
went out of their way to prevent this by indicating that there were two burials in
the church, but this was ignored by the authorities and the church was eventually
demolished. The tower today forms an unusual if not uncomfortable juxtaposition
with the modern shopping centre.

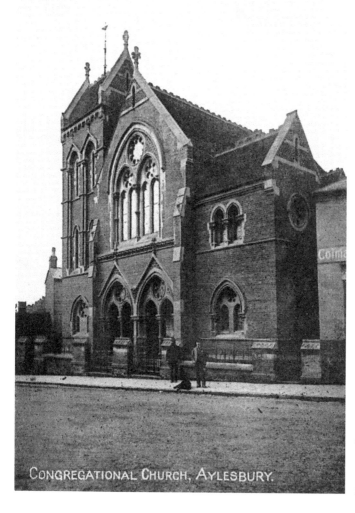

CONGREGATIONAL CHURCH, AYLESBURY.

The former
Congregational
Church, built
in 1874.

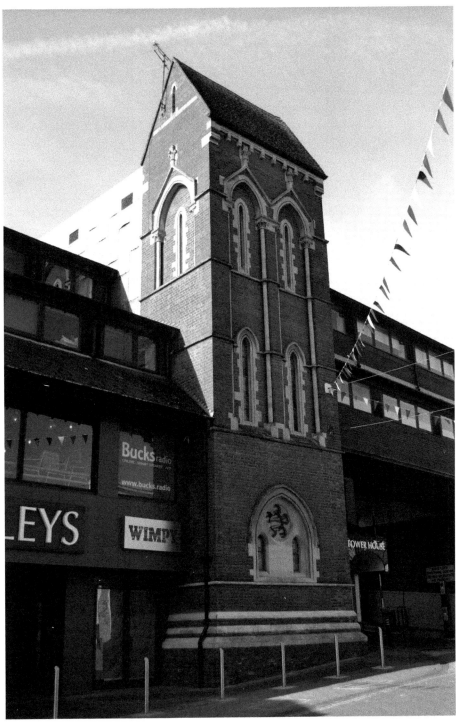

At least the tower survived, but it is a weirdly strange juxtaposition of architecture in the heart of Aylesbury.

32. The Clock Tower

Market Square is the historic trading centre of the town, and indeed markets are still held here weekly today. The site at the centre of the square was formerly occupied by the market house, which served on the ground level as an open covered market. Stallholders would pay extra to have their market stall here. Above it would have been a town meeting room where the stallholders' fees were collected and kept. Often these upper chambers also served as a form of town hall. A similar market house is at the nearby town of Amersham. The market house was demolished in 1866. By this time markets, while still a popular occurrence, had been replaced in importance by regular and permanent shops.

Ten years later the clock tower was built on the site. Constructed of local stone and in the Gothic Revival style, it was designed by local architect D. Brandon, who was also responsible for the Corn Exchange and many other public buildings in the town. The clock tower, complete with a spire, sits on a slightly raised dais from the rest of the square and has been used as a platform from which important speeches have been made in the past. The horse troughs that had been placed adjacent to the clock tower when it was constructed have since been removed.

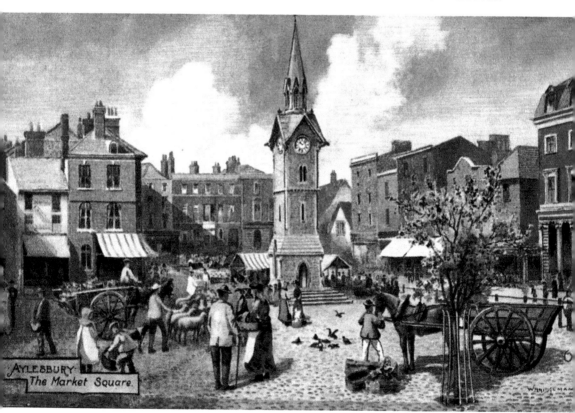

A romantic view of the Market Square.

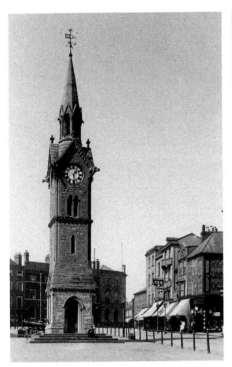 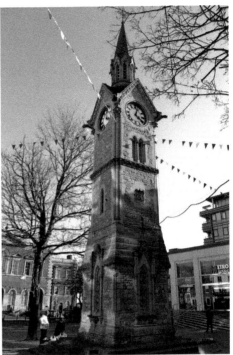

Above left: In the Gothic Revival style.

Above right: The Clock Tower, witness to many events in Aylesbury since 1876.

33. Hazel, Watson and Viney Print Works Gate Lodges

Hazel, Watson and Viney started as a printing business established by William Paul in Kirby Street, Hatton Garden, in 1839. In 1843, it was sold to George Watson, then working as a jobbing printer and stationer at Tring. He bought a new Hopkinson & Cope press, modernised the plant by introducing steam power and considerably expanding the enterprise, initially printing the temperance magazine *Band of Hope Review*. His printing contracts soon included the monthly *The British Workman and Friends of the Sons of Toil*. To these were added *Eclectic and Congregational Review*, *Alexandra Magazine*, *Woman's Social and Industrial Advocate* and *Family Mirror*. Walter Hazell (1843–1919) joined the firm in 1863 and it became known as Watson and Hazell. Hazell launched the *Illustrated Photographer* and *Amateur Photographer*, and also printed the *Marylebone Mercury*, the *East London Observer* and the *Bucks Independent*.

In 1867, the firm opened a branch in Aylesbury and in 1873 another branch in the Strand, London. When John Elliott Viney joined the firm as a partner in 1875, it became Hazell, Watson and Viney. A merger with Ford and Tilt of Long Acre

Street, London, in 1884 saw the firm change its name again, this time to Hazell, Watson and Viney Ltd, valued at £138,000. The 1890s saw the printing of some sixty newspapers and periodicals at Kirby Street. The legal and commercial printing division was located in Long Acre Street while books were mainly produced at Aylesbury. In 1869, the head office was moved from Kirby Street to Charles Street; in 1889 to Creed Street, Ludgate Hill; and finally in 1901 to Long Acre Street. The Kirby Street works were closed in 1920 and moved to Aylesbury and Long Acre Street. In 1878, the Aylesbury branch was moved to Tring Road in Aylesbury, undergoing periodic expansion from 1885 onwards. By 1939 the firm's employees numbered 1700.

Walter Hazell, born 1 January 1843, was the only surviving son of Jonathan Hazell. As chairman he played an active part in the company's affairs for some fifty years, and was a social reformer and women's suffrage supporter who wrote a number of pamphlets on social issues. He was also the Liberal Member of Parliament for Leicester between 1894 and 1900, and was instrumental in introducing an employees' sick fund in 1874 – one of many such welfare schemes that marked the firm as progressive.

Several generations of the Viney family played a major part in the running of the company. Hazell's grew after the Second World War as part of the Hazell Sun group of companies, and in 1963 became the British Printing Corporation,

All that remains of the former print works of Hazel, Watson & Viney Ltd.

A sign of times from the town's
industrial past.

one of the most influential printing and publishing organisations in Britain. The
company no longer operates in Aylesbury and has since been dissolved.

These two late 1930s classical gate lodges from the former Hazel, Watson and
Viney print works in Aylesbury have been rebuilt around the entrance of the Tesco
supermarket that now occupies the site.

34. Former Literary Club

Temple Street is characterised by eighteenth- and nineteenth-century buildings
that range between two and three storeys in height with narrow frontages that
face directly onto the street. The exception to this pattern of development is Nos
7–11, which dominates the north-eastern side of the street – the former Literary
Club. Constructed between 1879 and 1880, the building was extended in 1903
and again during the latter half of the twentieth century. It was designed for
Nathan de Rothschild by the renowned architect George Devey and originally
housed a library and reading room, and now contains a restaurant. It is a
flamboyant and highly decorative building, and its wide frontage is articulated
with an eye-catching two-storey oriel window and other windows of varying
size and detailing. The scale and decorative complexity of this building provides

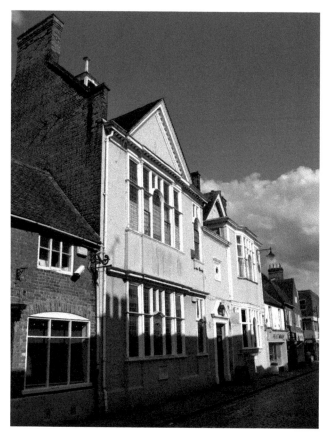

The former Literary Club, originally housing a library reading room.

a strong visual contrast with the relatively simple and modest eighteenth- and nineteenth-century elevations of adjacent properties.

Above the door is an architraved and corniced recess with the initials 'NR' enclosed by wreath bearing the Rothschild motto, 'Concordia, Industria, Integrita', which means 'Unity, Integrity, Industry'. Today, the former Aylesbury Literary Club stands in the midst of a busy town. From the earliest days the objectives of the club were 'the promotion of social intercourse and the provision of refreshments'.

35. Masonic Hall, Ripon Street

Arguably the most visually prominent building in Ripon Street is the Aylesbury Masonic Hall, which is situated on the south-western side of the street close to the junction with Whitehall Street. It was built in 1882 in the Victorian Gothic style and combines red brickwork with stone dressings. The building is symmetrical with a central two-storey bay protruding slightly forward of two side wings. The windows are lancet in shape with stone surrounds and the central doorway is decorated with stone columns topped with ornately carved capitals.

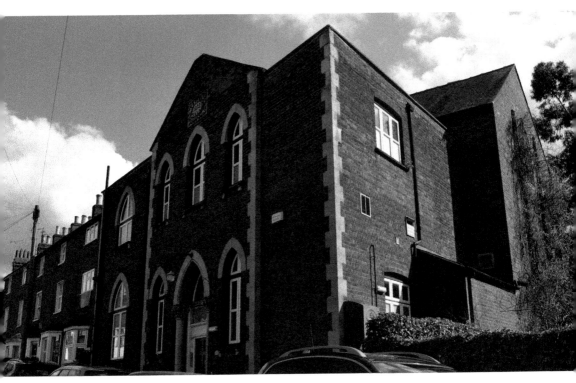

The Masonic Hall on Ripon Street.

36. Byron, Milton and Spenser Villas

Located a short distance to the south-east of Walton on the south-western side of Wendover Road between Milton Road and Spenser Road are Nos 115–145 Wendover Road, a row of very attractive late Victorian buildings. Of particular note are the three villas called Byron, Milton and Spenser, which are situated at the south-eastern end of the group. Built in 1893, these substantial detached buildings are situated slightly back from the road behind a low brick wall and metal railings.

The buildings maintain many of their flamboyant original architectural features, including ground-floor bay windows and highly ornate open porches. This relatively short row of buildings forms an attractive and architecturally cohesive group of late nineteenth-century development. Victorian development has had a significant visual impact upon Aylesbury. The group of large villas situated along Wendover Road represent a more affluent housing type than the simple and modest vernacular nineteenth-century buildings located on Granville Street and Ripon Street. The buildings are flamboyant in their detailing and large in scale, and due to their relatively good state of preservation arguably represent some of the most interesting and attractive examples of surviving Victorian architecture within the town.

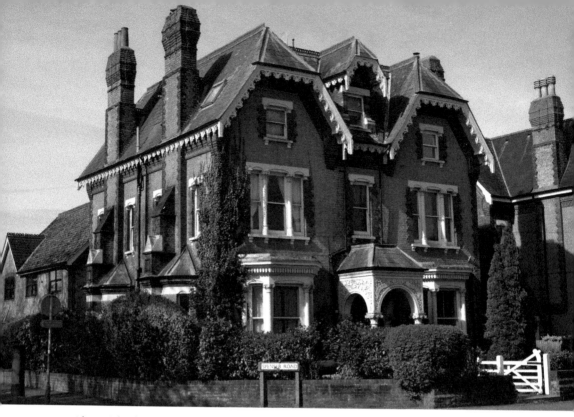

Above: The fantastic Spenser Villa, the epitome of Victorian decadence.

Below: Byron Villa, less flamboyant than its neighbour Spenser Villa, is now a care home.

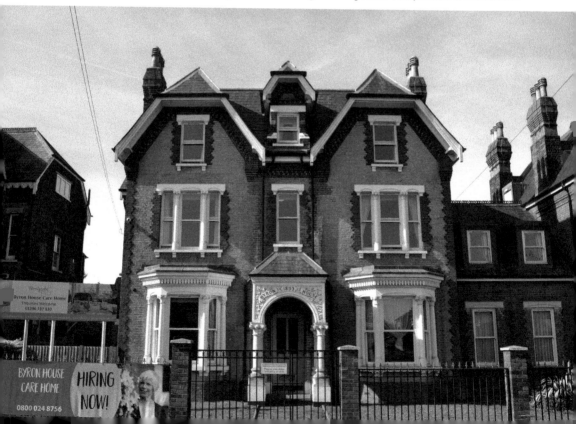

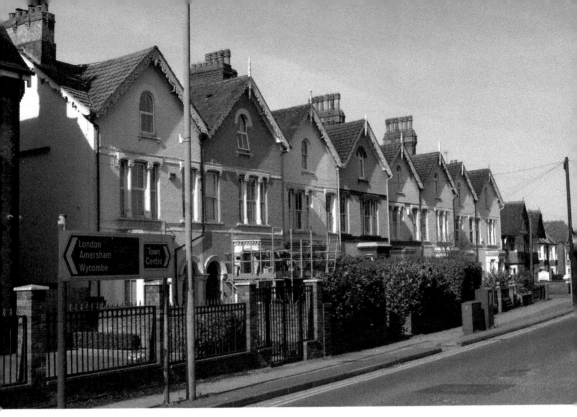

Fine examples of Victorian architecture on Wendover Road.

37. Methodist Church, Buckingham Street

Architectural critic Nikolaus Pevsner described this wonderful building as having a 'terrible Italianate style'. Today, it is much loved and although completely out of keeping with Buckingham Street and any other building in Aylesbury, it is a magnificent piece of architecture. It was built in 1894 for a congregation of over 700. Pevsner may have had his views, but it was certainly unusual for such denominational buildings to be so architecturally rich. This church has Byzantine and Romanesque features along with Italianate and was designed by architect James Weir, a British Wesleyan Methodist architect who designed mainly for the Wesleyan Methodist Church in London and the south-east of England. Weir's chapel output could have been greater had not commercial interests governed his career so strongly from 1890 onwards. For many years he acted as architect to the Victoria Chambers Company in Westminster (where his professional offices were situated) and to the Westinghouse Brake Company, which had set up in King's Cross, the area where Weir was brought up.

Later additions were made including a hall and Sunday school, designed by architect Fred Taylor. These buildings were opened by Mr Lionel de Rothschild OBE on 21 April 1921.

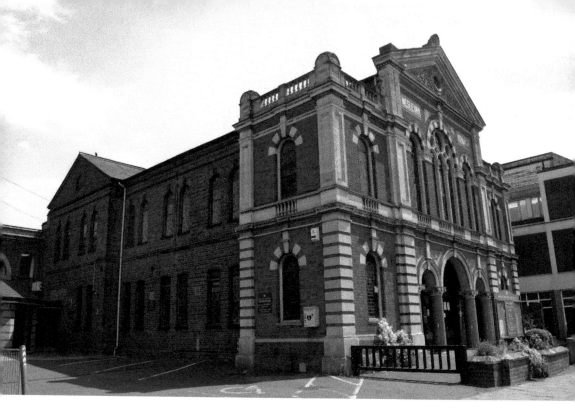

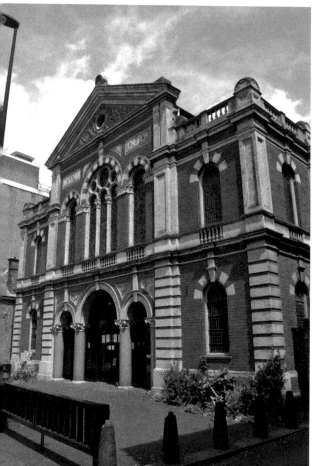

Above: The magnificent Methodist Church on Buckingham Street.

Left: Are there any better building façades in the town than the Methodist Church on Buckingham Street?

38. The Former Queens Park County School, now an Arts Centre

Tucked away behind rows of houses is the former Queen's Park County School. It was the first in Aylesbury to be built by the county council under powers given to them by the 1902 Education Act. It had places for 390 boys, 350 girls and 310 infants, providing an education for children from the age of five to fourteen years old.

The Edwardian building is now occupied by Queens Park Arts Centre, which opened in 1980. Along with the infants school were two similarly designed buildings – located to the east of the main site on what is now a housing development – acting as the boys' and girls' junior school. The school kitchen is now the centre's dance studio, while the painting studio stands on the site of a storage facility formerly used by the county education department.

Famous students at the school include the poet Vernon Scannell and local music heroes John Otway and Wild Willy Barrett, who've returned regularly to perform at the centre's Limelight Theatre. John has often remarked that he takes great delight in his old classroom now being the Limelight Bar; while Willy recalls being paid by the headmistress to blow up the tyres on her car during breaktime, unaware it was he who had let the air out in the first place.

The school was used as a hospital facility during the First World War, and a plaque in the foyer commemorates the staff and 'old boys' known to have fallen during the conflict. Queens Park School was closed down in 1976.

Now Queens Park Art Centre, but once a school.

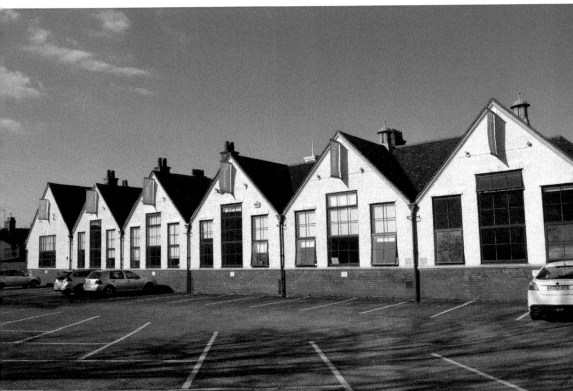

Aylesbury Grammar School was founded in 1598 following a bequest from Sir Henry Lee of Ditchley, the champion of Elizabeth I, and its first home was in St Mary's Church in Aylesbury. It later moved to the buildings that now house the County Museum until 1907, when it moved to its present site. For many years the school was independent, and its intake was co-educational. In 1952, it became voluntary controlled and in 1959 the girls moved to a separate site to become Aylesbury High School. Links with the girls' school are retained through joint activities such as school concerts, plays, dances and theatre visits.

In 1714, Henry Phillips left a further sum of £5,000. By the terms of the will the sum upon trust was to be applied 'for the purchase of lands of inheritance in fee simple in the county of Bucks … for the enlargement and further provision for the Free School in Aylesbury … There were to be 120 boys admitted, to be taught gratis and to be furnished with books, pens, ink and paper, gratis'. Some £4,000 of the bequest was invested in farm property in the manor of Broughton. Ten trustees were appointed by the High Court in 1717. They were the first trustees of what is now the Aylesbury Grammar School Foundation.

By the mid-1880s the inadequacies of the school site were becoming apparent, particularly the lack of games facilities. The old buildings were deteriorating and there were suggestions that fees of £4–6 might be charged with provision of scholarships for poorer boys on grounds of merit from public elementary schools of the district. The search for a new site began. A committee was established in the name of Aylesbury Grammar School and support from local charities was sought for the provision of a new site for the school. The charities were also approached with a view to making some provision for girls. In 1902, the Balfour Education Act was passed, which laid the foundations for the country's secondary education. The county council was permitted to raise money for secondary education from local rates, and on 2 July 1903 a new scheme under the name of Aylesbury Grammar School came into existence.

In 1904, Lord Rothschild of Tring agreed to sell about 8 acres of land adjoining Turnfurlong Lane at £170 an acre to the foundation trustees. The purchase price was £1,406 10s. During Easter 1907 the school transferred from the old buildings in St Mary's Square, where it had been since 1611, to its present site. The old buildings were sold in two lots: Lot One was bought by the Architectural and Archaeological Society for the purpose of housing a museum and Lot Two was acquired by St Mary's Church. The school's modest investments were sold by the trustees, and Buckinghamshire County Council offered a grant of £2,000. The cost of the school was to be £6,000 and the headmaster's house £1,500, with an additional £250 for laying out the frontage and fencing. Lord Rothschild donated shrubs for the front of the school. Some 400 people attended the opening ceremony at which Lord Rothschild was presented with a silver key mounted with

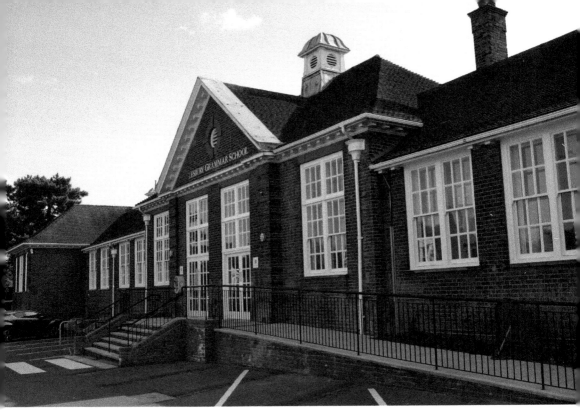

Above: Aylesbury Grammar School, once used as a military hospital.

Below: Ancillary buildings to Aylesbury Grammar School.

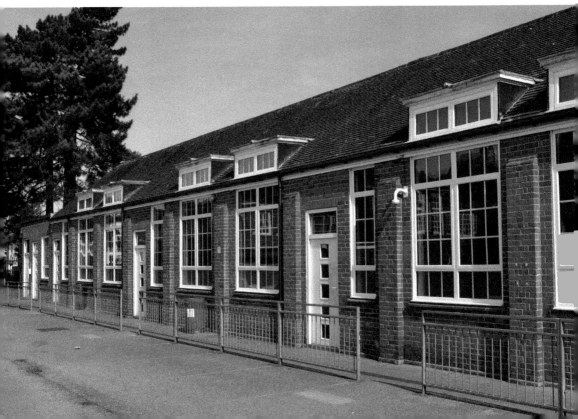

the Aylesbury arms. The new school would accommodate seventy-five boys and seventy-five girls.

The Aylesbury Grammar School Foundation trustees owned all the property, which was held in trust for the benefit of the school. There was a separate governing body that managed the school – a position that continues to this day. In October 1914, the school premises were requisitioned by the War Office for a military hospital and the school moved to temporary accommodation in and around Kingsbury and St Mary's Squares. A flock of sheep grazed the cricket pitch. Staffing problems became acute and boys were withdrawn to compensate for the loss of farm labour because of conscription. In September 1919, 220 pupils were readmitted to the school. Twenty-one former pupils had died in the war; their names are inscribed on the memorial stone that was unveiled two years later. In 1922, there was a sixth form of twenty pupils. The next twenty years could be described as a period of consolidation of the co-educational grammar school, and by 1939 numbers had grown to 346.

During the Second World War, Ealing County Boys' School was evacuated. Aylesbury pupils attended classes here in the morning and Ealing pupils in the afternoon. A bomb fell on Walton Grange in September 1942 and though the effect of the blast was considerable, the school was soon repaired. In 1956 the county council decided to create two single-sex schools, with the foundation being attached to the boys' school, which would benefit from the foundation's income. The new girls' school was built and major capital work – including the tower block in 1963, six laboratories in 1964 and an extension to the hall in 1965 – was completed at Aylesbury Grammar School.

40. HSBC, Market Square

The former London Joint City & Midland Bank was built by Webster & Cannon and opened on 30 May 1921. Today it is HSBC. Opposite the front door of the bank is the statue of Benjamin Disraeli. He eventually became prime minister as a result of the law changing in 1858 with the passing of the Jewish Relief Act. He was Member of Parliament for Buckinghamshire, Chancellor of the Exchequer and prime minister twice. He remains the only Jewish leader of our country to date. His road to becoming prime minister was challenging as he fought against his rival William Gladstone and was the victim of anti-Semitic racism throughout his campaign.

Disraeli's statue stands on the same corner of the town's Market Square and faces that of John Hampden. Both of these grand statues were made by the sculptor H. C. Fehr. It was not straightforward for Fehr as the works were delayed by the beginning of the First World War, but he eventually completed his work in 1923. Disraeli is shown wearing the robes of the Chancellor of the Exchequer.

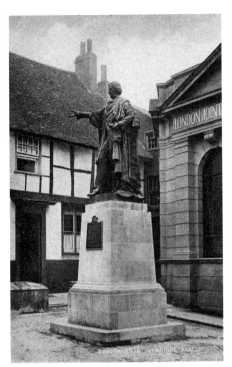
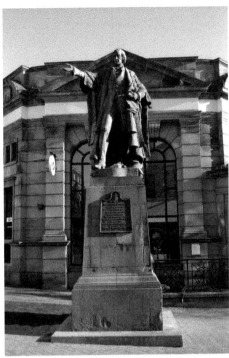

Above left: Disraeli and the London Joint City Bank and Midland Bank.

Above right: Disraeli wearing his robes as Chancellor of the Exchequer.

Below: Today the HSBC bank.

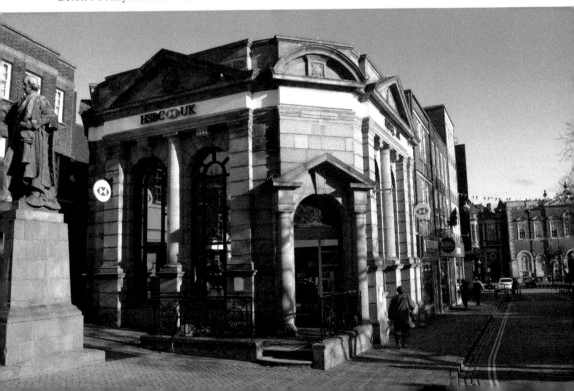

The statue of John Hampden opposite the bank.

41. Hampden House

Hampden House at the junction between the High Street and Vale Park Way is one of the town's most interesting modern buildings. It is in a style seldom seen elsewhere. Conceived as an office block for an international company, its curved façades hint at a revival of the streamline modern. This is further enhanced by the upper floors themselves appearing as bands of brickwork and glass. Streamline moderne is an international style of art deco architecture and design that emerged in the 1930s. Inspired by aerodynamic design, it emphasised curving forms, long horizontal lines, and sometimes nautical elements. In industrial design it was used in railroad locomotives, telephones, toasters, buses, appliances and other devices to give the impression of sleekness and modernity

Hampden House – streamline moderne in style.

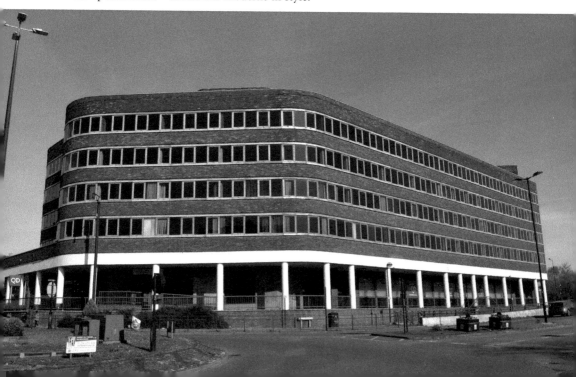

The large store on the ground floor is recessed into a faux arcade of a lighter stonework than the upper floors, providing a mixture of light and shade in an almost baroque effect of chiaroscuro to the more solid floors above.

42. Old Aylesbury Police Station

On Tuesday 8 October 1935 the new Aylesbury police station and constabulary headquarters in Exchange Street were opened by Sir Walter Carlile, Chairman of the Bucks Standing Joint Committee. In his opening address he paid 'a high and well-deserved tribute to the efficiency of the County police and said the problem Colonel T. R. P. Warren, the Chief Constable, had tackled had been a stiff one but the work done spoke for itself'. After the opening ceremony the guests were able to witness the despatching of a message by the aid of the teleprinter from Sir Walter Carlile to the whole of the police in the county, in which he said that in no county in England did there exist a police force more united, more efficient, more happy and content or more loyal to its best traditions.

The buildings were erected at a total cost of £14,461 by Messrs Webster & Cannon, the well-known and reputable Aylesbury-based builders – at that time one of the largest in southern England. The design was by C. H. Riley, the county architect who had also designed the 1929 County Offices in Walton Street, so it was not surprising that they harmonised. The buildings provided the police with modern and up-to-date facilities, including a low-pressure heating and hot water system, which served both main buildings – quite revolutionary at the time

The former police station, now a restaurant.

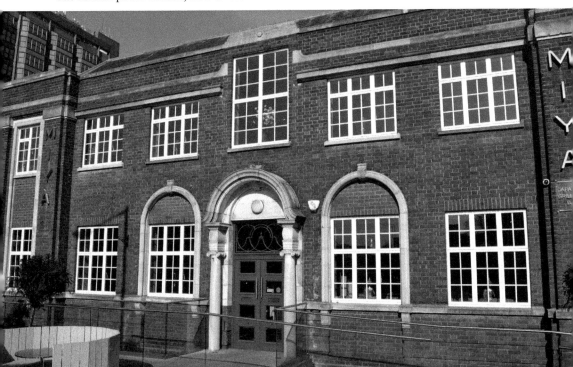

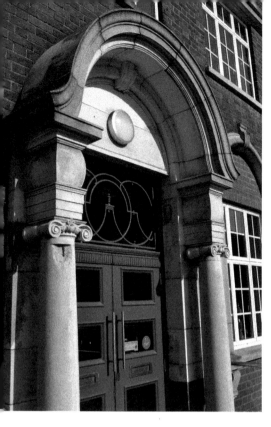

The impressive entrance to the former police station.

and a major feature of five telephone lines connected to the local exchange. The *Bucks Herald* at the time said, 'They provide the police with modern and up-to-date buildings equipped with all the latest and scientific apparatus where police administration can be conducted in an efficient manner.' The complex comprised of the county constabulary headquarters and recreation club; Aylesbury local police station, with an attached inspector's house and accommodation for four single constables; and a superintendent's house. It is also interesting to note that the level of the ground floors of the new buildings were identical with those of the basement of the County Offices, so it would be possible to link up the two buildings if required at any time in the future.

The buildings eventually became redundant and surplus to police needs with the site put up for sale but was bought by a local business and is now a popular restaurant – one of Aylesbury's most iconic buildings saved, unlike many before it.

43. Former Gala Bingo

The current building seen here is closed and has been for a number of years. The site was originally a Pavilion cinema, which opened its doors in 1937, and then a Granada in 1946 before it closed in 1972. It then became a Granada bingo hall before changing its name to Gala Bingo in 1991. Latterly, the site had been a Buzz Bingo. It has been under threat since then with a number of uses proposed, including an arts and music centre, and some requests to see it opened as a bingo hall once again.

The former Gala Bingo – currently without a purpose.

44. County Offices

Around 1929 it was realised that County Hall and the office complex behind the Corn Exchange was too small for the increasing bureaucracy of Buckinghamshire County Council. The county architect C. Riley was commissioned to design a large office block in keeping with the perceived architecture of the town. The resultant County Offices was a three-storey building of seventeen bays in an almost Second Empire design. The flat façade is given interest by slight projection of the terminating bays and a low stone portico at the centre. On the first floor the centre window, and the windows at the centre of the terminating bays, were given pediments. Otherwise, the façade beneath a mansard roof is unadorned. This unremarkable building, completed in 1939, is indistinguishable from the street architecture found in any English city of that era, and adds little to the market town architecture of Aylesbury. In time the County Offices themselves came to be regarded as the County Hall, as the machinery of the county court gradually took over the older County Hall in its entirety. If the architecture of the 1930s County Hall was considered out of keeping with the town, thirty years later came an even more controversial building, albeit of greater architectural interest – Aylesbury's most recent and present County Hall immediately opposite.

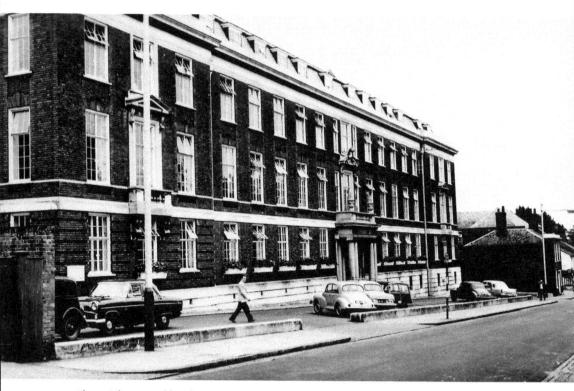

Above: The seat of local government in 1939.

Below: Important to local democracy, County Hall here is somewhat unremarkable.

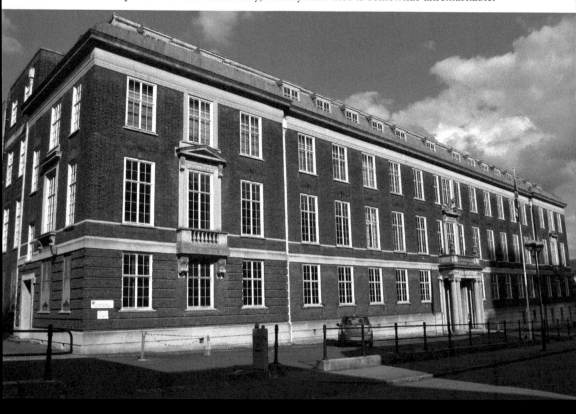

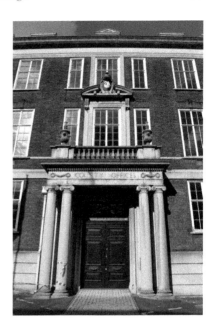

County Offices – a fine entrance to a fairly uninteresting building.

45. Grange School

Grange School has often been billed as the biggest school building project since before the Second World War. It was built as a secondary modern school under the 1944 Education Act and had places for over 600 pupils. It was opened in 1954. In 1959, the school was visited by Princess Marina, Duchess of Kent in celebration of the 10th anniversary of Mother's Clubs in Buckinghamshire. The school is notable as the location where the jury retired to consider their verdict in the Great Train Robbery case of 1963. They used the room that is now the main office of the youth centre on the school site.

Grange School, which opened in 1954.

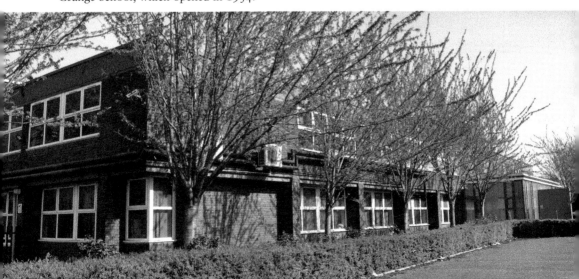

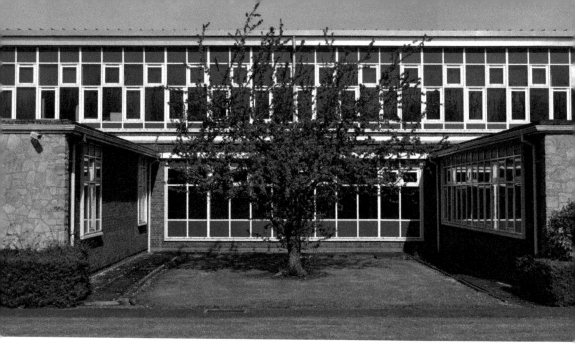

Grange School, with connections to the Great Train Robbery of 1963.

46. New County Hall

In the mid-1960s a decision was taken to redevelop and replan a large central part of the town, providing a new shopping centre, bus station and County Hall. Following Aylesbury's long history of using the in-house county architect rather than employing a more eminent one, Frederick B. Pooley came to design his most monumental and controversial work. Pooley was experienced in the design of schools having drawn the plans for three educational establishments in the town Quarrendon County Secondary School in 1959, the Grange Secondary Modern School in 1954, and Oak Green Primary School in 1950. Pooley's choice of architecture was brutalist, an architectural style sometimes referred to as 'the celebration of concrete', its chief building component, the first example of this style in the town.

Many old shops and historic buildings were demolished to clear the site. The new town centre was tiered. An underground bus station had a three-floored department store above, while on the same level as the bus station was what was commonly referred to as an underground market – a large hall containing an assortment of small market time stalls and boutiques.

Above this was an open pedestrian square around which were larger shops and a cafeteria. The cafeteria in itself was an amazing feat of architectural engineering, as it was built high on stilts – the better to view the 1960s architecture. While this form of town planning is often scorned today, at the time it provided exactly what was required by its consumers: greater shopping choices with easy access and convenient public transport, all in a modern environment, contrasting with the wartime building restrictions that had lingered in Britain until the previous decade.

While at the time the people of Aylesbury and the surrounding district were mostly happy with their new shopping centre, more controversial was the new County Hall, the foundation stone of which was laid on 22 October 1964 by Sir Henry Floyd, Lord Lieutenant of Buckinghamshire. This building entirely of concrete and glass stands 200 feet high and consists of fifteen floors. Dominating a predominantly eighteenth-century town of low-brick houses, it proved to be a conversational piece of architecture. The new County Hall sits above a complex containing the County Reference Library, Aylesbury Register Office and the County Record Office. Inside, it bought together for the first time all the departments and machinations of the former Buckinghamshire County Council. The building is visible from many villages and towns several miles distant, thus residents of Buckinghamshire are constantly aware of the location of their seat of local government. Often referred to locally as 'Pooley's Folly' (after the architect), the building took just two years to build and was completed in 1966 at a cost of £956,000.

With its brutalist roots in the 1940s and earlier, Aylesbury's County Hall was, like its classical predecessor, already dated by the time of its 1966 completion. By then architecture was moving on to the cleaner and straighter lines and

Below left: The new County Hall is controversial but makes a significant statement to the town's architecture.

Below right: Brutalism at its best – or most brutal.

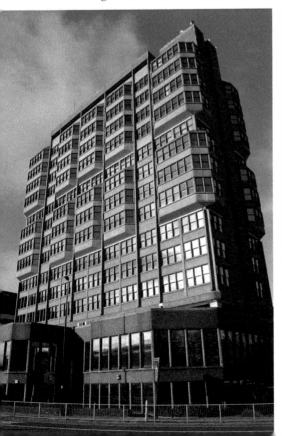
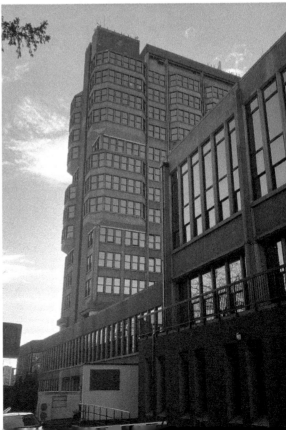

sheets of plate glass advocated by such architects as Mies van der Rohe. County Hall, though, does possess identity and boldness of design, and an architectural abrasiveness accentuated by the heavy contrasts of glass and dominating concrete. Today its architectural merit is recognised and the building is listed for preservation as Grade II. Though never at the cutting thrust and pioneering end of modern architecture, as its patrons required, the new County Hall is now very much part of the landscape, as much a part of the provincial architecture as any of its older neighbours. It prevents the town appearing as a time capsule and represents the reality of a busy, functioning industrial town as opposed to a museum piece, which some other historic town centres have become.

47. Guardian Angels RC Church, Southcourt

The first post-Reformation Catholic church was opened in Aylesbury in 1892: a temporary iron church that was in use until 1935, when it was demolished to be replaced by the current St Joseph's Church in Aylesbury High Street. With the expansion of Aylesbury in the 1950s, a site for a new church was purchased in Southcourt in 1952. But it was not until June 1963 that a timber church hall was opened at Southcourt as a temporary church.

The early 1960s was the time of the Second Vatican Council, which had a profound effect on the appearance of many Catholic churches and would surely have influenced the wide open space created inside the Guardian Angels Church at Southcourt.

Guardian Angels RC Church.

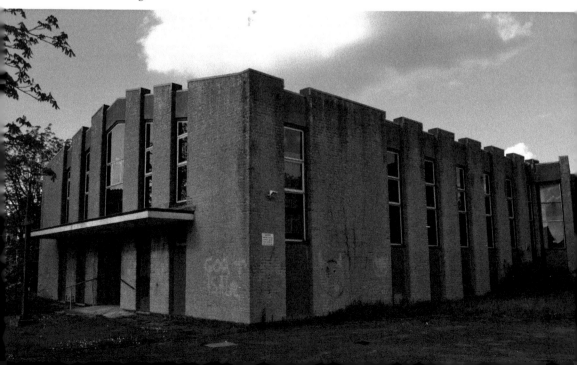

Plans for a new church had been drawn up by the architect M. J. Plester, based on a concrete frame by Crendon Industrial Buildings of Long Crendon, and work started in January 1967. A great amount of the building work was done by volunteers, and the large building (around 28 metres, or 92 feet long) was opened on 12 July 1967, and actually in use by 1 October 1967 but is sadly no longer in use today.

48. The Blue Leanie

One of the most iconic buildings in Aylesbury is known as the 'Blue Leanie' and when spotted from the main roundabout at the end of Walton Street, one can see why. It is made of glass and brick with walls that slant, giving it the name 'Blue Leanie'.

The building was designed for Equitable Life in 1982 and architecturally is known as an oblique rhombic prism, standing at an angle of 170° inclination. It has proved controversial over many years, from its opening to more recently. It has often been claimed to affect motorists with the sun reflected onto its inclined and mirrored surfaces. This even made the national press. This has since been resolved with the planting of mature trees, softening the site and making it less hazardous. There have also been complaints from tenants when air-conditioning fails with temperatures reaching 36 degrees centigrade.

The building has recently been refurbished by London & Scottish Investments Ltd and its setting much improved by high-quality landscaping.

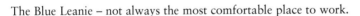

The Blue Leanie – not always the most comfortable place to work.

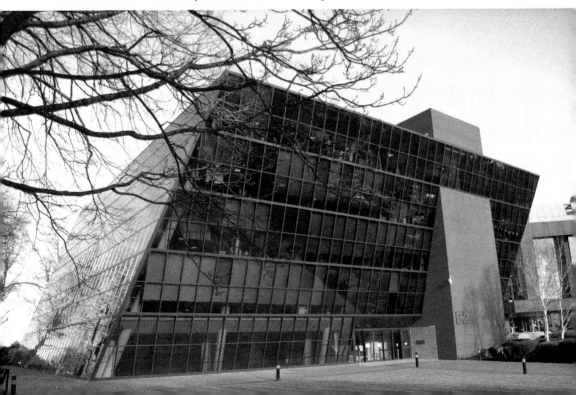

49. Aquavale Leisure Centre

This facility in Vale Park was opened on 15 September 2001. With the aid of Lottery financing the cost was £9.8 million. The centre has three swimming pools: an eight-lane, 25-metre competition pool complete with movable floor; an indoor leisure water pool with a lazy river and an interactive flume; and a heated outdoor pool, which is available for use throughout the year. Much of this contrasts with the adjacent Vale Park. In the late 1880s all that was present in this location was a cricket ground with a pavilion. Several years later, landscape architect Thomas Mawson was asked to produce plans for a new park, eventually submitted by his son Edward Prentice Mawson. Thomas Mawson was especially well known for designing many parks across the country, including Burslem Park and Hanley Park in Stoke-on-Trent as well as Haslam Park, Preston, and Stanley Park, Blackpool. Much of Mawson's plans, though, were adapted by the local council due to high costs. The park today is very popular, but one wonders what Mawson would have made of the introduction of the Aquavale Leisure Centre.

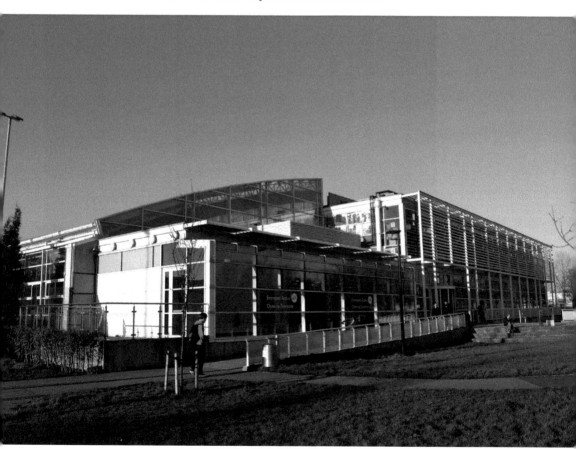

A recent introduction to Vale Park.

50. Waterside Theatre

The Waterside Theatre is one of the most iconic buildings in Aylesbury and is instantly recognisable. In 2003, the Aylesbury Vale District Council held a public consultation for plans for a new theatre in the town to replace the Civic Centre Theatre, which had been built in 1975. The town was in need of a multipurpose venue as the old theatre had been largely outgrown by its audience. The architectural team commissioned in 2007 was led by Norman Bragg for London-based architects Aedas and the RHWL Arts Team. A ceremony to mark the commencement of building work was held on 24 May of that year, with Councillor Sue Polhill, Chairman of Aylesbury Vale District Council, cutting a sod from the earth. The building work was carried out by Hertfordshire-based contractors Willmott Dixon.

At the time the theatre was given planning permission in 2006, it was expected to cost £25 million. When the contractor Willmott Dixon was appointed in 2008, the cost had risen to £35 million. By the time the theatre opened in 2010 the

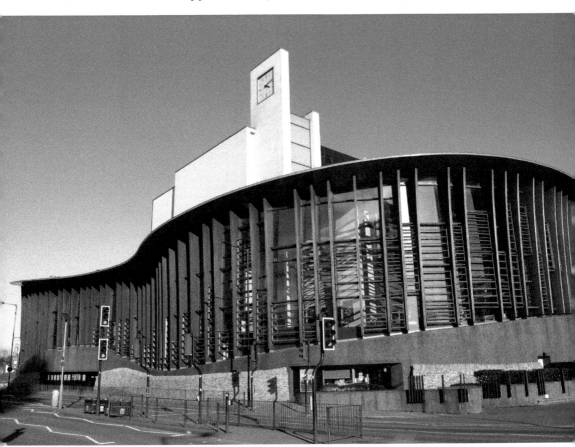

Aylesbury Waterside Theatre – one of the town's most iconic buildings.

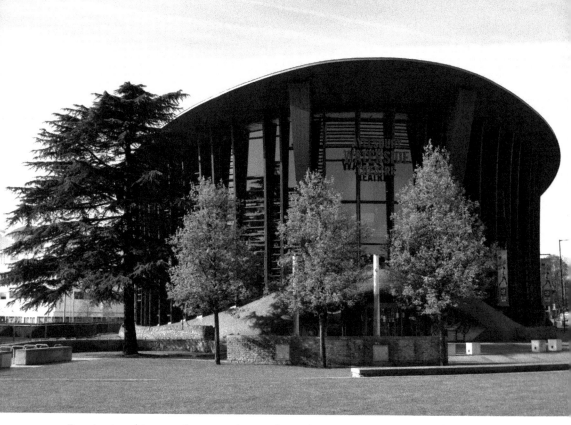

Dominating this part of town and part of a major regeneration strategy, the theatre was opened in 2010.

final cost had risen again to £47 million. The council appointed Ambassador Theatre Group (ATG) to manage the theatre. Aylesbury-raised actress Lynda Bellingham marked the completion of the highest part of the building work on 24 April 2009 with a traditional topping out ceremony.

In a joint press release on 23 February 2010, Ambassador Theatre Group and Aylesbury Vale District Council announced that the theatre would open on 12 October 2010. The first season went on sale on 23 March 2010 with Northern Ballet's *Swan Lake* set to be the first performance.

Aylesbury Waterside Theatre was officially opened on 12 October 2010 by Cilla Black.

Bibliography

Birch, Clive, *The Book of Aylesbury* (Chesham: Barracuda Books Ltd, 1975)

Cook, Robert, *Around Aylesbury* (Stroud: Alan Sutton Publishing Ltd, 1995)

Gibbs, Robert, *A History of Aylesbury* (British Library, Historical Print Editions, 1887)

Hanley, Hugh and Julian Hunt, *Aylesbury – A Pictorial History* (Chichester: Phillimore & Co. Ltd, 1993)

Hanley, Hugh, *Aylesbury: A History* (Chichester: Phillimore & Co. Ltd, 2008)

May, R., *Aylesbury in Old Picture Postcards* (European Library, 1989)

May, A. R., *Aylesbury in Old Picture Postcards Volume 2* (European Library, 1994)

Mead, W. R., *Aylesbury – A Personal Memoir from the 1920s* (Aston Clinton, 1996)

Moxley, Yvonne, *A–Z of Aylesbury: Places, People, History* (Stroud: Amberley Publishing, 2019)

Parrott, Hayward, *Aylesbury Town – Yesterdays* (Waddesdon: Kylin Press Ltd, 1982)

Pevsner, Nikolaus, *The Buildings of England – Buckinghamshire* (London: Penguin Books, 1979)

Vaughan, Karl, *Aylesbury Past & Present* (Stroud: Sutton Publishing Ltd, 1998)

Vaughan, Karl, *A Century of Aylesbury* (Swindon: Sutton Publishing Ltd, 2002)

Viney, Elliott and Nightingale, *Pamela, Old Aylesbury* (Luton: White Crescent Press Ltd, 1981)

Acknowledgements

I would like to thank my wife Julie for putting up with me on the many trips back and forth to Aylesbury when the sun was shining, just to get a slightly better photograph than I had already taken. Page, Plant, Bonham and Jones remain forever an inspiration in all that I do. Thanks also to all the fantastic people at Amberley Publishing who allow me to write and seem to like publishing me. It is appreciated.

About the Author

Paul Rabbitts is a Fellow of the Royal Society of Arts and a Fellow of the Royal Historical Society. He is currently Head of Parks and Open Spaces for Southend-on-Sea City Council and is also a prolific author on local history, architecture, public parks and a noted expert on the history of the Victorian and Edwardian bandstand. He has written several books in the 'in 50 Buildings' series, including Watford, Leighton Buzzard, Luton, Salford, Bournemouth, Windsor and Eton, Manchester, Carlisle, Welwyn and Welwyn Garden City, as well as biographies on the architects Decimus Burton and Sir Christopher Wren. His website is www.paulrabbitts.co.uk.